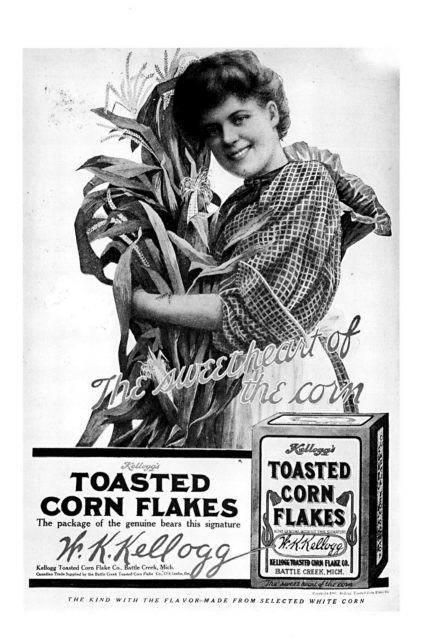

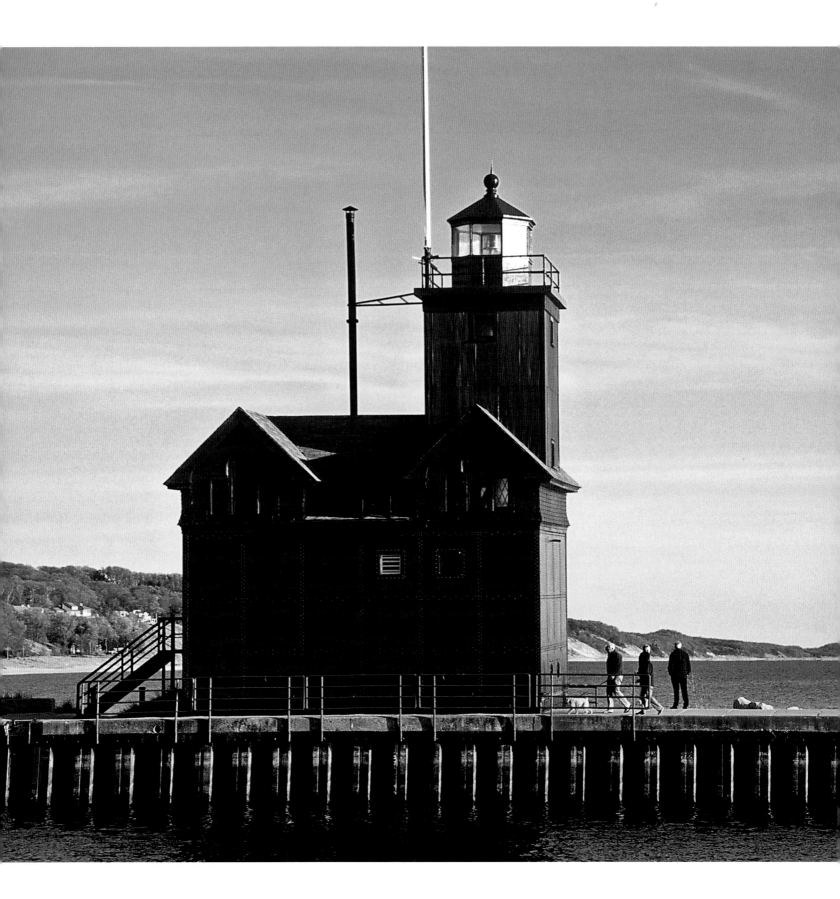

MICHIGAN
YESTERDAY & TODAY

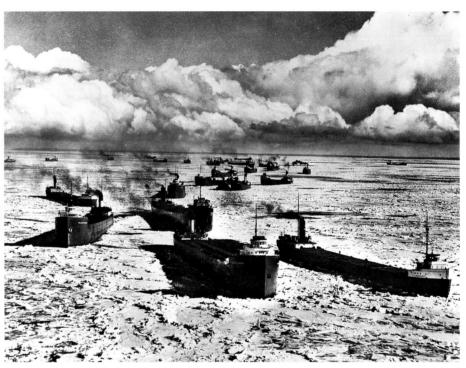

ROBERT W. DOMM

Voyageur Press

Dedicated to
Charlie & Pansy
&
Herb & Wanda

Library of Congress Cataloging-in-Publication Data

Domm, Robert W.

Michigan yesterday & today / Robert W. Domm.

p. cm.

Includes index.

ISBN 978-0-7603-3385-3 (hb)

1. Michigan—History—Pictorial works. 2. Michigan—Pictorial works. 3. Repeat photography—Michigan. I. Title. II. Title: Michigan yesterday and today.

F567.D665 2009

977.4'040222—dc22

2008048594

Edited by Danielle Ibister
Designed by Jennie Tischler
Printed in China

Front cover: *Logger.* Superior View

Frontispiece: *Kellogg's Corn Flakes advertisement, circa 1910.* Archives of Michigan

Title page main: *Holland Harbor Lighthouse*

Title page inset: *Icebound freighters in Whitefish Bay, circa 1950.* Superior View

Contents: *Fountain on Detroit's Riverwalk*

ACKNOWLEDGMENTS

I would like to thank the following people who have helped make *Michigan Yesterday & Today* a successful and memorable project. A big thank you to Nancy Stone at the Crawford County Historical Society, Maureen Ballenger at the Otsego County Historical Society, Rosemary Michelin at the Marquette Historical Museum, and Lori Rose at the Delta County Historical Society. Thanks to Michael Schragg for the tour of his amazing Postal Museum in Marshall. To Mark Eby of Castle Rock; Janice Vollmer and Bill Johnson at the Call of the Wild Museum; Leslie Earl at Sea Shell City; and Sandra Koukoulas and Hanne Nielson at Pewabic Pottery, thank you for sharing your stories and for your hospitality. Thanks to Jack Deo at Superior View for all the great photos. Thanks to Jennifer McDonough at Seney National Wildlife Refuge for dropping everything to help me find historical photos and to Scott Reynolds for all the laughs and for your help in Grayling, Vermontville, and, along with Ashleigh Reynolds, at the cider mill. Thanks to Michael Dregni at Voyageur Press for all the postcards and to my editor, Danielle Ibister, for a great job.

To my parents, Bob and Mary Lou Domm, thank you for your unwavering support and for instilling in me a curiosity about the past. A special thanks to Ed and Bea Vergeldt for all the research they gathered for me and for their love and support. Everyone should have an Aunt Bea and Uncle Ed in their life. Above all, thanks to Donna, my wife, for everything you do and for your love.

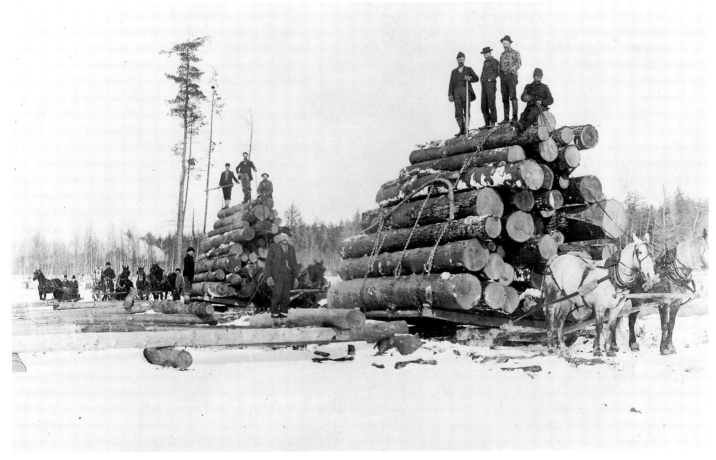

Cut logs being loaded on skids, circa 1890. Otsego County Historical Society

Contents

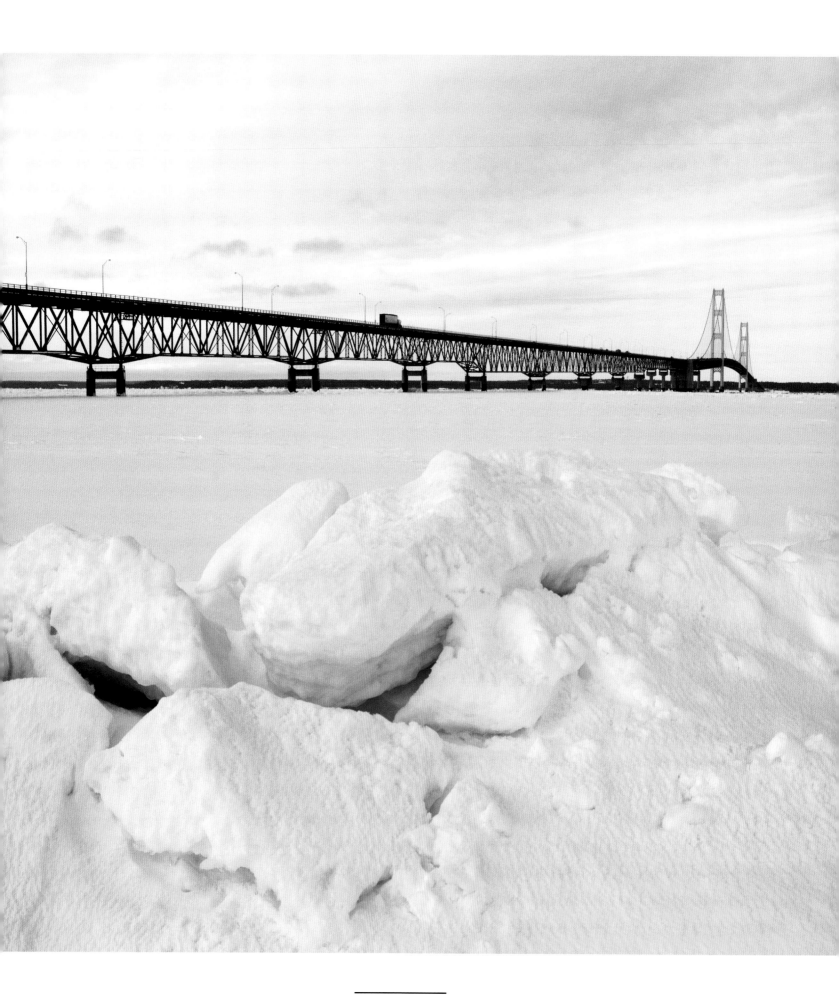

INTRODUCTION

One frigid morning in February, I exchanged quiet words of awe with another visitor, a stranger, as we stood together looking at Tahquamenon Falls. The words were spoken softly and reverently, as if a harsh word would shatter winter's spell and bring the sculpted pillars of ice that surrounded the falls crashing down. The connection that Michigan's people have with their state's historic places is apparent everywhere you go—in knowing glances between travelers at places of great beauty, in the enthusiasm of tour guides at historic sites.

To some, history is nothing more than a collection of dusty artifacts in a creaky-floored museum. But just as a library is simply a collection of books until the first cover is opened, history is more than displays of hand-wrought tools and fading photographs. History is the world as it appeared to our ancestors. The words they wrote, the tools they made, and the things they built speak volumes.

In public school and later in college, I was fortunate to have several teachers who went beyond presenting dates and facts and brought history to life. *Why*, not *when,* did Chief Pontiac lay siege to Detroit? How was it that Henry Ford's assembly line changed the very fabric of American life? These were the questions they asked and answered. By holding the hopes, fears, politics, and beliefs of our forebears up to the candle, history becomes a human saga and not just a timeline of events.

The history of Michigan and the continuing story of its people is an account of the pursuit of a better life. Material wealth came to some—the timber barons, mine owners, railroad men, inventors, and industrialists—while most faced hardship in the forests, mines, farmsteads, and factories. The common thread that binds all those who came here through the years is the chance Michigan provided to start fresh in a land of opportunity; and I believe that spirit is still very much alive in our state.

Researching, writing, and photographing *Michigan Yesterday & Today* took well over a year to complete. Beyond that, I have called on a lifetime of experiences in my home state and have been privileged to share the recollections and stories of many of my fellow citizens. I hope this book encourages you to keep the stories alive and to appreciate the lives and events that have brought us to where we are today.

—Robert W. Domm
September 2008

The Mackinac Bridge

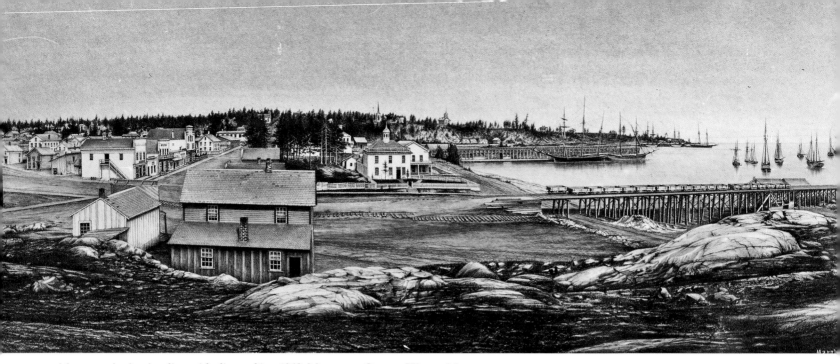

Marquette harbor bustling with clipper ships, 1863. Marquette County History Museum

An unused ore-loading dock

MARQUETTE

The port of Marquette sits snugly on the shores of Lake Superior, steeped in history and surrounded by natural beauty. Founded in the mid-nineteenth century on the shore of a natural crescent-shaped harbor, the town became the main shipping port for the iron ore mines of the nearby Marquette Iron Range. When the Soo Locks opened at Sault Sainte Marie in 1855, Marquette began a rapid expansion that included a series of ore-loading docks that stretched out into Marquette Bay. The old docks are no longer in use, but it is still possible to sit in Presque Isle Park near downtown and watch workers load ore boats from newer loading docks that stretch out into the harbor.

Like many cities in Michigan, Marquette has expanded into suburbs in recent years. Downtown, however, remains an eclectic mixture of beautifully restored nineteenth-century Jacobson sandstone buildings mixed with other styles of architecture. Marquette has a definite "college town" feel, owing to the presence of Northern Michigan University; its waterfront parks make it one of Michigan's most livable cities.

Many institutions have come and gone around Marquette, driving the city's economy before being replaced by something new. Natural resources still play an important role in the city's economy, and the timber and mining industries are still strong in the area. Following World War II, nearby K. I. Sawyer Air Force Base drove much of Marquette's economy. When the base closed in 1995, it was one of the Upper Peninsula's largest employers, with nearly five thousand locals on the payroll. Today, Marquette is home to the largest health care provider in the UP, Marquette General Health System.

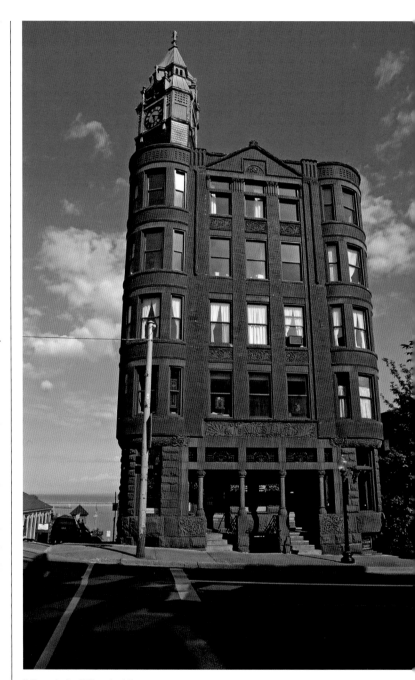

Historic building in Marquette

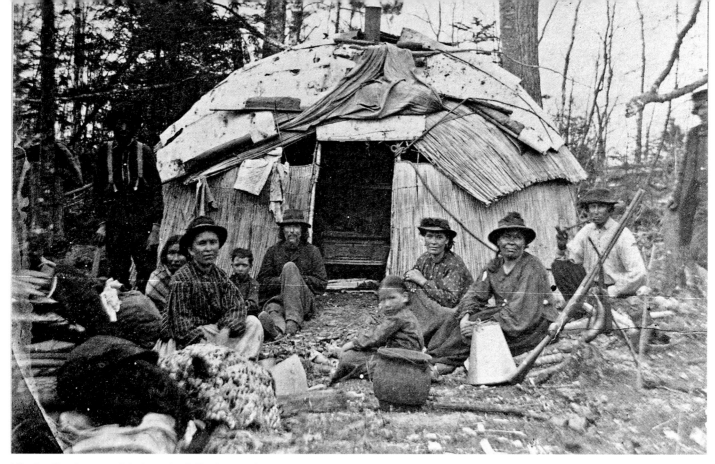

The family of respected Ojibwa chief Charles Kawbawgam, 1889. Marquette County History Museum

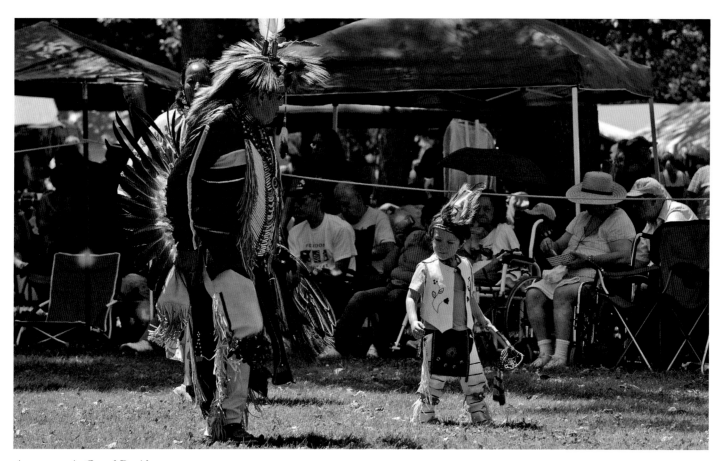

A powwow in Grand Rapids

ANISHINABEK

They harvested the bounty of Michigan's forests, lakes, and streams from Lake Superior to western Lake Erie; dressed in fur and feather; and sheltered under sturdy wigwams and lodge houses made from animal hides and bark. They greeted Michigan's first European explorers, the French, who probed northern North America, establishing trade routes and spreading Christianity. Later, they fought bravely for their homeland as Europeans moved into Michigan. They were the people of the Three Fires Confederacy: the Odawa (Ottawa), Ojibwa (Chippewa), and Potawatomi. They are Anishinabek, which means "The Original People."

Michigan's original people belonged to what is now called the Late Woodland Culture, a sophisticated social and economic confederation of tribes associated by culture, trade, and blood. In pre-European times, most of these tribes lived as hunter-gatherers, moving around the Great Lakes to take advantage of seasonal supplies of food. As European influence grew, many tribes abandoned their seasonal travels and took up residence along newly established trade routes, supplying the French and, later, the British with the frontier's new currency: furs.

During the nineteenth century, Michigan's native people were overwhelmed and displaced by the loggers, miners, and settlers who poured into the new state. The original people soon became economic outcasts with little opportunity to compete with European immigrants for mining or lumbering jobs. Forced onto reservations, they struggled against poverty and loss of cultural identity.

In the late twentieth century, organizations like the American Indian Movement helped rekindle tribal identity and pride. By banding together, sharing resources, and taking advantage of rights granted under treaties, many of Michigan's tribes have grown to become regional economic powerhouses. Today's reservations are self-governing and self-policing entities that are moving toward economic parity with their neighboring communities.

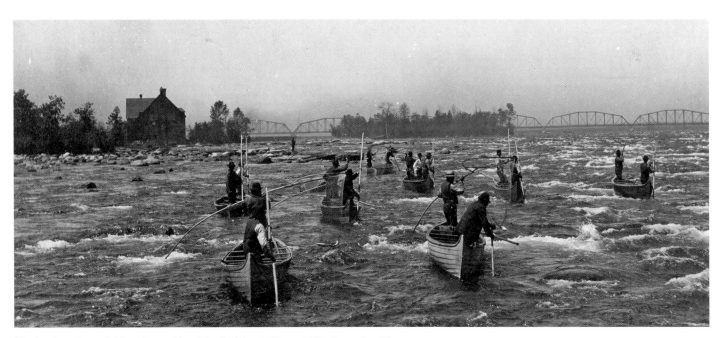

Native Americans fishing the rapids of the St. Mary's River, 1901. Superior View

MINERS CASTLE

The towering sandstone cliffs of Lake Superior's Pictured Rocks have found a place in the writings of every missionary and explorer who passed beneath them, and has awed travelers from the aboriginal Chippewa to modern-day vacationers. Jutting into the lake and standing tall against the sky is Miners Castle, one of Pictured Rocks' most recognizable icons. Even before Pictured Rocks became a national lakeshore in the 1960s, Miners Castle was a popular stop for tourists exploring the Upper Peninsula.

Over the millenniums, the wind, the ice, and the pounding surf of Lake Superior have slowly eroded the cliffs, carving new grottos in the soft stone and fashioning fresh designs in the cliff face. But the ever-changing façade of Pictured Rocks is not always a slow and imperceptible process. Walk along the Lakeshore Trail atop the cliffs and look (carefully!) over the side into the lake two hundred feet below. Lying in the clear aquamarine water are boulders and slabs of stone (many the size of small houses) shed by the cliff face over the years. The permanence of Pictured Rock's stone fortifications is an illusion.

Between 1995 and 2007, at least five major landslides occurred within Pictured Rocks National Lakeshore, sending large portions of the cliff face crashing into Lake Superior. The yearly cycle of freeze and thaw opens fissures in the soft sandstone, especially in the spring and autumn, weakening its integrity. Gravity eventually does the rest.

On the morning of April 13, 2006, a fisherman trolling offshore near Miners Castle reported that the taller, northeast turret of the formation had broken away and fallen into the lake. The remaining stone parapet of the castle still strikes a majestic pose against the backdrop of Lake Superior and tourists still flock to the viewing platform every summer, but the empty perch once occupied by the northeast tower stands as a reminder of the constantly changing face of nature.

Miners Castle inspires painters and photographers.

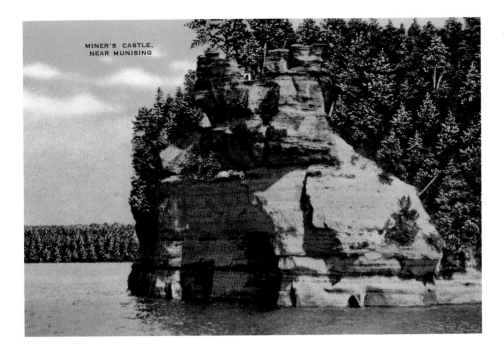

MINER'S CASTLE,
NEAR MUNISING

Historic Miners Castle, circa 1941.
Voyageur Press archives

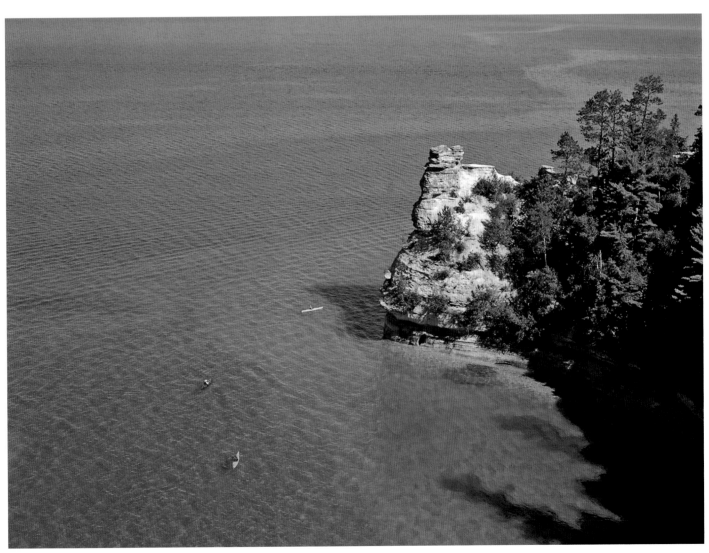

Modern Miners Castle

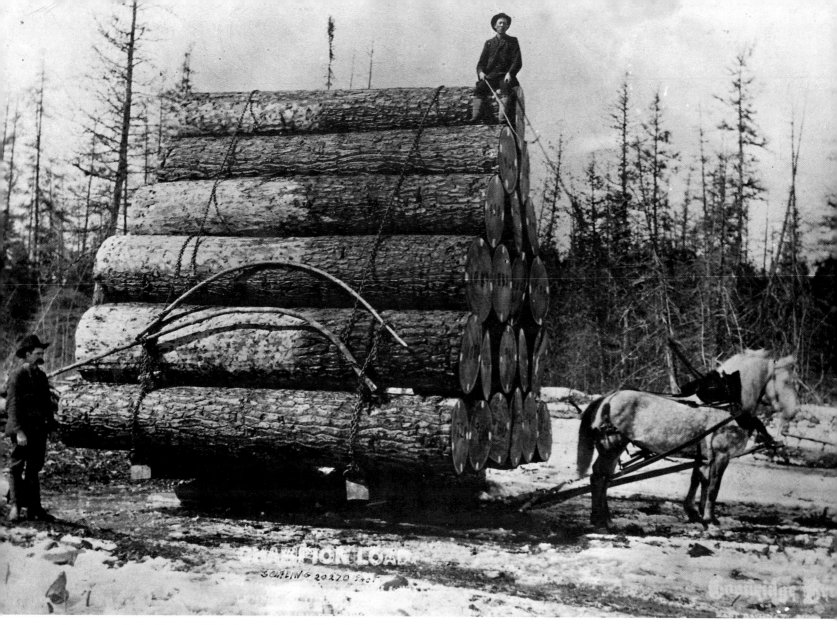

A winter-cut load of lumber, 1890s. Otsego County Historical Society

Lumbering team, 1880s. Otsego County Historical Society

THE TIMBER INDUSTRY

A s the automobile industry would in the twentieth century, the timber industry shaped the economic landscape of Michigan in the nineteenth century. Workers from all over Europe and the eastern United States flocked to Michigan to man the whipsaw and sawmill as lumber barons purchased and then clear-cut the state's forests. Along the coasts of the Great Lakes, towns sprang up around sawmills and deepwater ports. Many of Michigan's largest cities got their start as mill towns that processed the seemingly endless supply of timber from the state's interior forests.

When the timber finally did run out, the careless and shortsighted logging practices of the timber companies left Michigan facing one of America's first environmental disasters. Forest fires fed by dried logging slash raged across the state, destroying towns from coast to coast. With the tree cover gone, erosion washed tons of soil into rivers and streams, destroying fisheries and clogging waterways with silt. Only through an aggressive reforestation program and careful forestry management have Michigan's forests returned to health.

Today, the lumber industry still plays an important role in Michigan's economy, and archaic and thoughtless lumbering

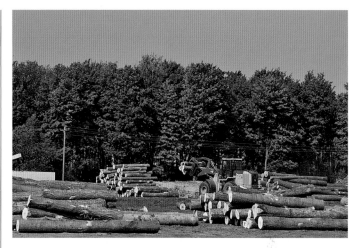

Several hundred small lumber mills still operate in Michigan.

practices are now firmly in the past. Michigan's timber industry produces a variety of products, from dimension lumber and veneer to pulpwood, while employing more than 150,000 people and adding $10 billion to the state economy. Careful management of vast timber resources have kept the state's forest products flowing into the world's marketplace while keeping the forests themselves healthy.

Logging Museum in Hartwick Pines State Park

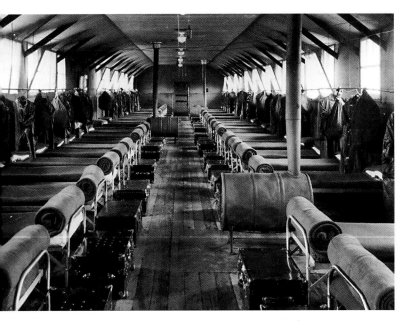

CCC barracks, circa 1935. U.S. Fish and Wildlife Service

Trees planted by the CCC

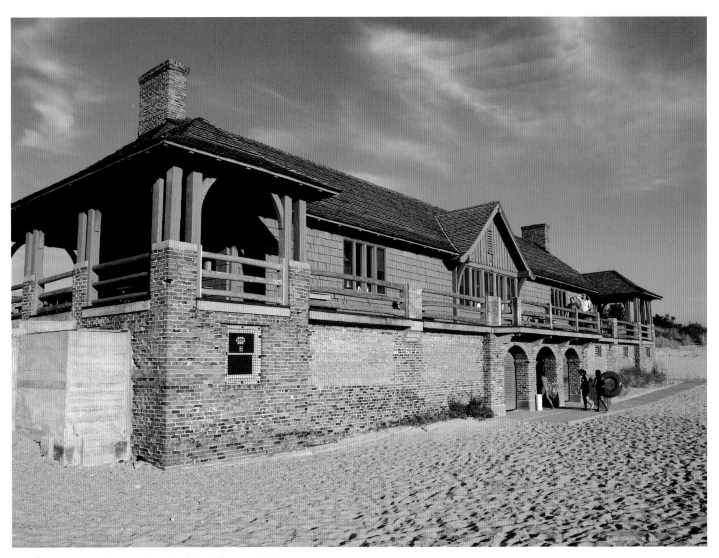

Beach house at Ludington State Park built by the CCC

THE CIVILIAN CONSERVATION CORPS

I n 1932 amidst the bleak depths of the Great Depression, the Civilian Conservation Corps (CCC) came to Michigan. Record unemployment had left many Michigan families with no breadwinner and its young people with little hope for the future. Clear-cut logging of Michigan's forests had left behind an eroded landscape that was prone to flooding and forest fire. The people and the landscape of Michigan badly needed a helping hand.

In the hopes of putting 250,000 unemployed young men to work on public conservation projects, President Franklin Delano Roosevelt received permission from Congress to form the CCC. The mission of the CCC was to work on federal and state land to prevent forest fires, floods, and soil erosion—an undertaking that Michigan badly needed. Against this backdrop of devastation and despair, the first contingent of two hundred young men from Detroit was dispatched to the Upper Peninsula in May 1933. By the end of the year, eight thousand young men lived and worked at forty-one CCC camps in northern Michigan.

The CCC camps had a distinctly military flavor. Camps were run by regular or reserve Army officers and discipline was tight. Michigan's CCC recruits built fire towers and fire breaks in state and national forests, built roads and bridges, improved and stabilized hundreds of miles of rivers and streams, released millions of hatchery-born game fish, and planted 484 million trees. In Michigan's fledgling state park system, the men built concessions, bath houses, conference centers, campgrounds, and beaches—structures that are still serving Michigan's citizens today.

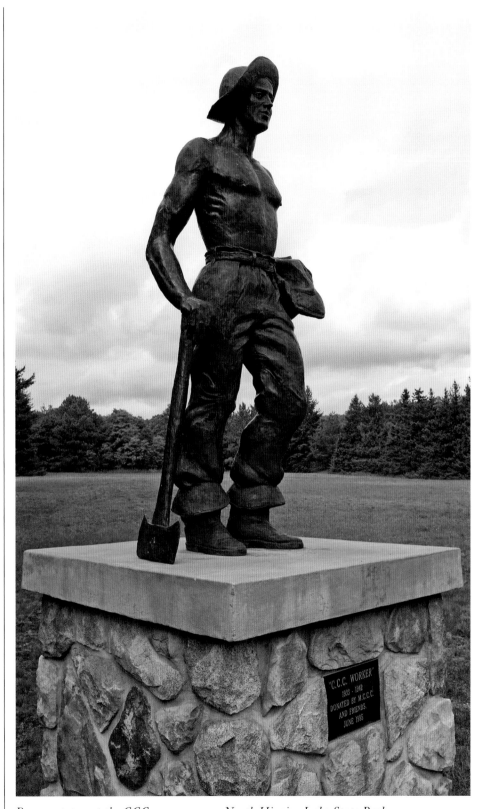

Bronze statue at the CCC museum near North Higgins Lake State Park

TAHQUAMENON FALLS

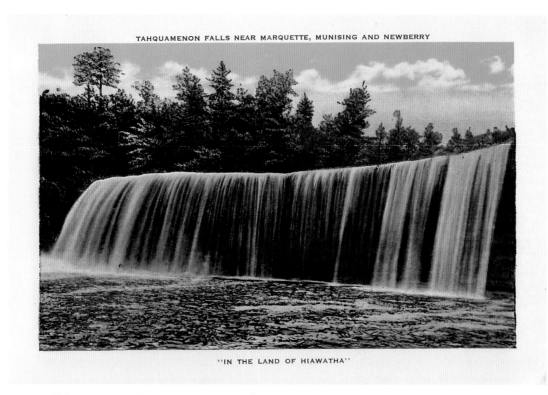

TAHQUAMENON FALLS NEAR MARQUETTE, MUNISING AND NEWBERRY

"IN THE LAND OF HIAWATHA"

Historic Tahquamenon Falls. Voyageur Press archives

The Tahquamenon River and its roaring falls have been inspiring the people of Michigan since the days when the Ojibwa hunted, fished, and trapped along its wooded banks. The fictional warrior Hiawatha sang the river's praises in Henry Wadsworth Longfellow's poem "The Song of Hiawatha," and French fur trappers and their native guides paddled and portaged the river into the interior of Michigan's wild forests. The Tahquamenon River drains nearly 790 square miles of cedar, spruce, and hemlock forest. At peak flow, it sends upwards of fifty thousand gallons of tea-colored water cascading over the fifty-foot-high falls every second. The roar of the two-hundred-foot-wide cascade discourages casual conversation, drawing your senses instead toward the rainbow of mist rising from the base and the spray-drenched branches of the trees growing along the precipice.

Tahquamenon Falls and the fifty thousand acres of undeveloped, trackless forest that surround it are now part of Tahquamenon Falls State Park, the second-largest state park in Michigan. The park boasts a modern campground, paved trails to both the upper and lower falls, and a reconstructed logging camp that serves food and refreshments. For the first time in over a century, moose once again roam the park's forests. Observant visitors can see the largest member of the deer family feeding in ponds and wetlands along the park's roadways.

Like many of Michigan's rivers, the Tahquamenon suffered severe environmental damage during the logging boom of the late nineteenth century. The Tahquamenon River Improvement Company, a creation of the Detroit, Mackinac, and Marquette railroad, blasted 16,000 cubic yards of bedrock out of the main river channel just above the upper falls during 1882 and 1883 to prepare the river for log drives when the railroad cleared the land upstream. The channel carved out of the river was one-half-mile long, eighty feet wide, four feet deep, and designed to drain thirty square miles of wooded wetland owned by the company. When the land upstream was cleared and the logs were floated down the river, a massive amount of sand and silt entered the river, destroying its fisheries. Today, through careful resource management, the mighty river and its surrounding forests have recovered from past abuses and are once again a source of inspiration for Michigan's citizens.

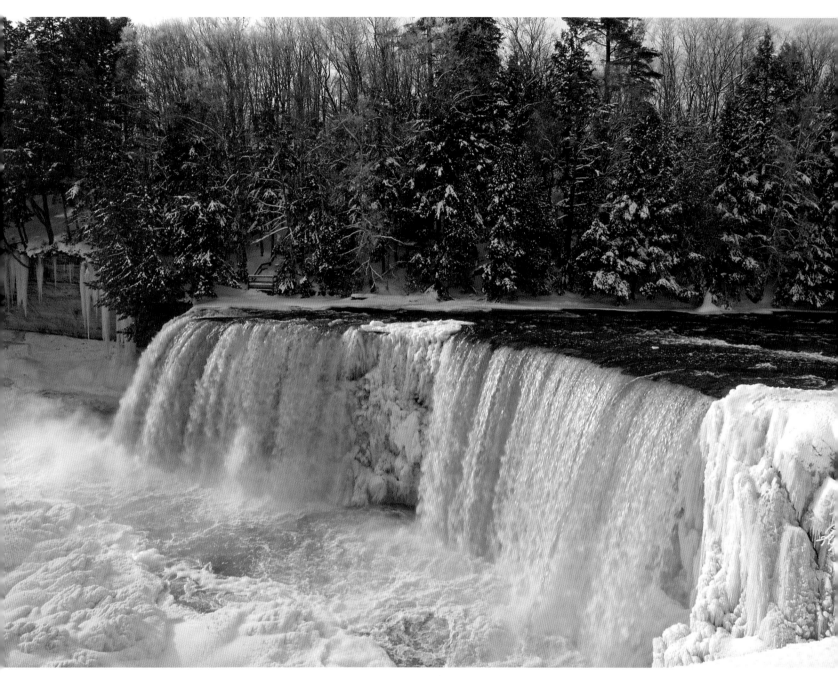

Winter at Tahquamenon Falls

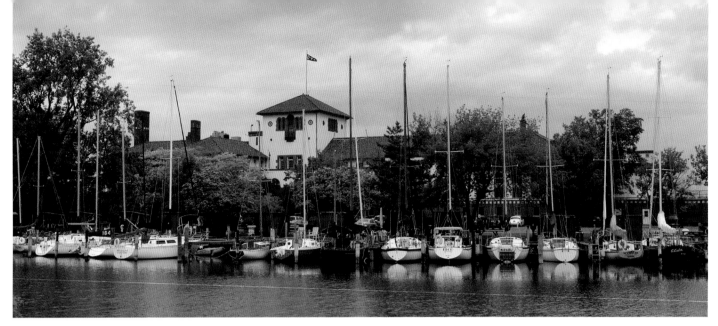

The Detroit Yacht Club

BELLE ISLE

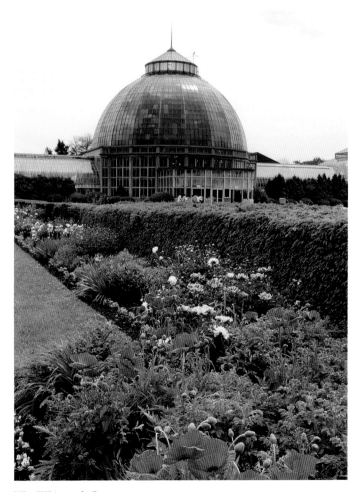

The Whitcomb Conservatory

The largest city-owned park in the United States lies midstream in the Detroit River, nestled between downtown Detroit and Windsor, Ontario. Purchased by the city of Detroit in 1879 for $200,000, the 985-acre island has served the city as an oasis of green space for over a century.

Belle Isle's stately public buildings and monuments were designed by two of the early-twentieth-century's most respected architects, Frederick Law Olmsted and Albert Kahn. Olmsted created the master plan for Belle Isle that would transform the wooded island into a world-class city park. Among Olmsted's

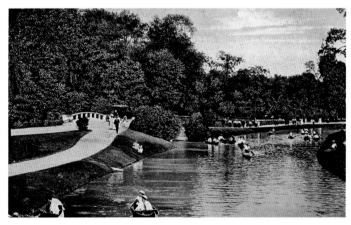

Nineteenth-century Detroiters enjoying one of Belle Isle's scenic canals. Voyageur Press archives

other achievements was the design of New York City's Central Park and the grounds surrounding the Capitol in Washington, D.C. Olmsted chose Albert Kahn, the design architect for Detroit's General Motors Building and Fisher Building, to design the Belle Isle Casino, The Belle Isle Aquarium, Whitcomb Conservatory, and the Livingstone Lighthouse.

The island is home to the Detroit Yacht Club, one of the oldest and largest yacht clubs in the world. Detroit's yachters share the river with a variety of Great Lakes freighters, making Belle Isle a great place to view the immense cargo vessels as they pass through. The island itself is crisscrossed by a series of canals that beg to be explored by kayak or canoe.

The MacArthur Bridge, a 2,193-foot-long concrete structure, has joined Belle Isle to the city of Detroit since 1923. Easy access has made the island park a favorite retreat for Detroiters during the summer months. In July, visitors can enjoy a front-row seat during Detroit's Freedom Festival, a fireworks display that celebrates the independence of the United States and Canada; in August, they can visit the island to view the Detroit Belle Isle Grand Prix auto race. Throughout the year, Whitcomb Conservatory, home to one of the largest orchid collections in the United States, entices visitors with six different flower shows.

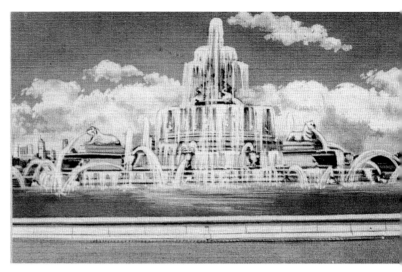

Historic Scott Fountain on Belle Isle. Voyageur Press archives

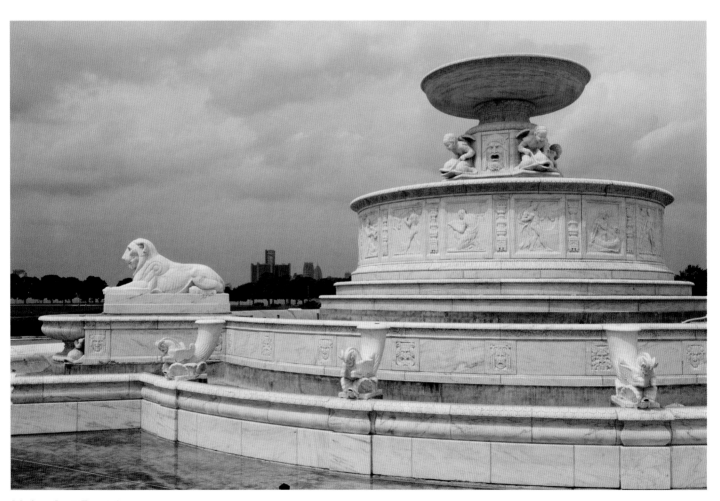

Modern Scott Fountain

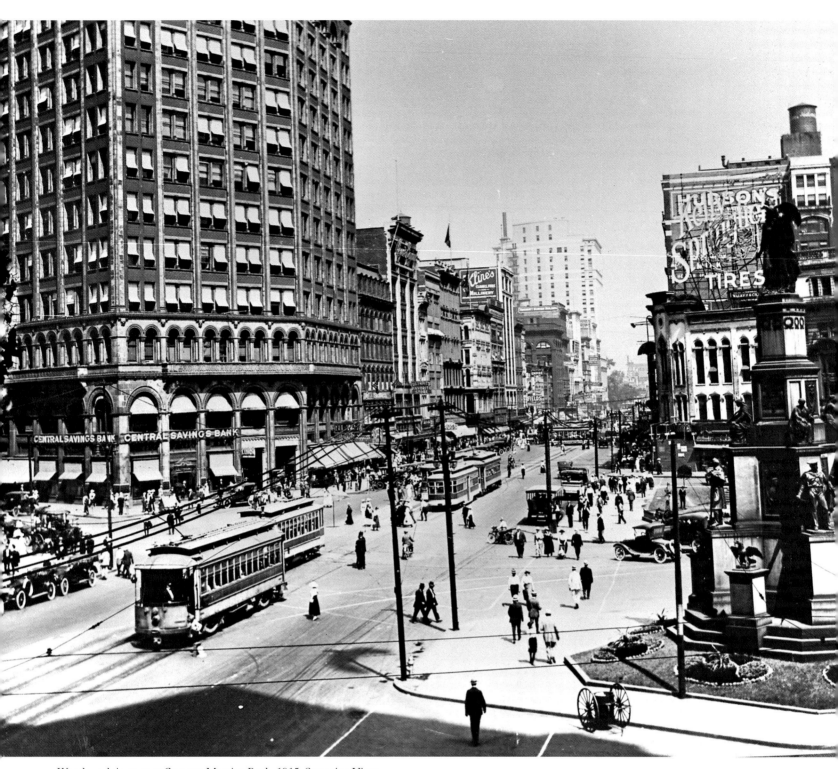

Woodward Avenue at Campus Martius Park, 1915. Superior View

DOWNTOWN DETROIT

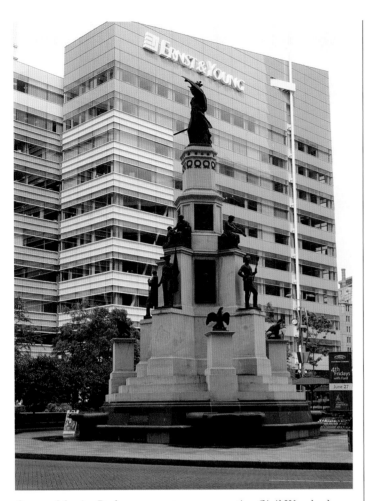

Campus Martius Park monument commemorating Civil War dead

the heyday of automobile manufacturing, Detroit grew to become America's fourth-largest city and one of its wealthiest. World-renowned architects designed and built masonry skyscrapers that would define the city's skyline for decades, including the Art Deco Fisher building, the Penobscot building with its twelve-foot neon orb on top, and the marble-floored Guardian building.

Today, the steel-and-glass towers of the Renaissance Center dominate Detroit's waterfront and skyline. In the shadow of the Renaissance Center is Hart Plaza, an outdoor venue for summer concerts and rallies. A newly developed river walk extends along the shore of the Detroit River from the Ambassador Bridge past the Renaissance Center to the MacArthur Bridge and Belle Isle, an ideal venue for a summer afternoon stroll.

R ising from its humble beginning as an eighteenth-century French outpost, Detroit epitomizes the spirit of America's great cultural and industrial cities. During Detroit's three-hundred-year history, the site was besieged by Chief Pontiac during the French and Indian War, captured by British redcoats, destroyed by a devastating fire in 1805, and ceded to the United States after the War of 1812. In the years leading up to statehood and the Civil War, Detroit was the gateway to Michigan's settlement. In 1837 alone, some 200,000 settlers passed through Detroit on their way to newly purchased farms in western Michigan.

Despite its long involvement in Michigan's history, Detroit's defining moment came in the early twentieth century with the invention of the mass-produced automobile. Ever since, Detroit has been known as the automotive capital of the world. During

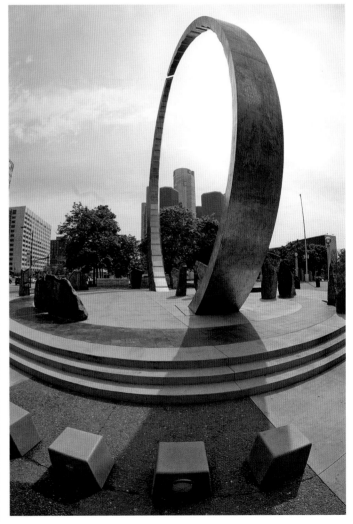

Sculpture in Hart Plaza honoring the city's ties with trade unions

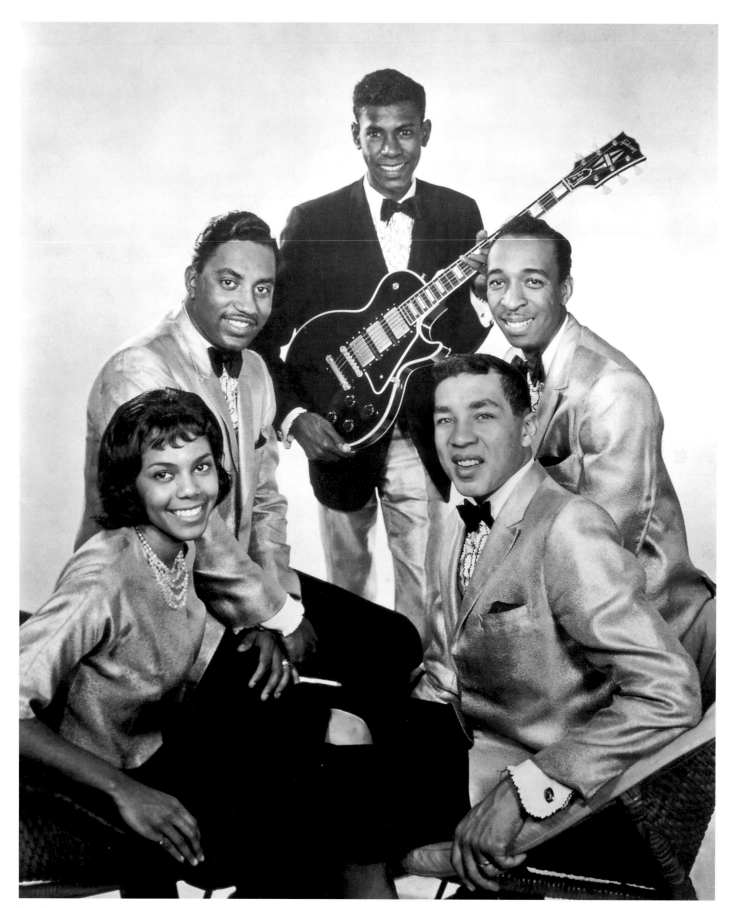

Smokey Robinson and the Miracles, circa 1970. Michael Ochs Archives, Getty Images

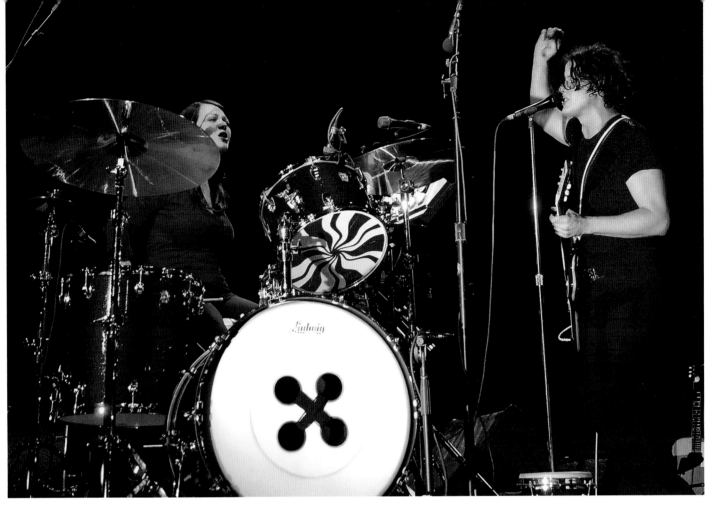

The White Stripes, 2007. Stephen Lovekin, WireImage, Getty Images

THE DETROIT MUSIC SCENE

With the rise of the automobile industry came a migration of workers to Detroit. People from all over the United States with all manner of musical taste converged on the city. Soon Detroit was awash in musical diversity. Autoworker-turned-blues legend John Lee Hooker rose to fame playing after-hours in Detroit's club scene, and the Queen of Soul, Aretha Franklin, nurtured her talents while singing in her father's Detroit church. Jazz and blues clubs thrived in Detroit's Paradise Valley African-American entertainment district, while gospel music poured out of the city's many churches. Detroit became an important link in America's new musical traditions.

In the late 1950s and early 1960s, Berry Gordy, a Detroit autoworker-turned-producer, began producing records that would soon put the city on the world stage. Gordy's studio on Detroit's West Grand Boulevard was called Hitsville USA, his record label was called Motown, and his recording artists read like a who's who of popular music. Smokey Robinson, The Temptations, Diana Ross and the Supremes, Marvin Gaye, and Stevie Wonder were just a few of the artists and groups that made up Detroit's Motown Sound, a musical genre that ruled the pop charts through the 1960s and into the early 1970s.

Detroit-based rock and roll bands also had a profound influence on popular music. The gritty, loud, raw rock and roll coming out of Detroit in the late 1960s and early 1970s was a direct contrast to the more mellow rock music of the Woodstock years. High-energy bands like the MC5, The Stooges, the Bob Seger System, and Alice Cooper paved the way for the hard-rock sound that dominated rock music well into the 1980s. Many groups and artists associated with Detroit have been inducted into the Rock and Roll Hall of Fame, including Glenn Frey of the Eagles, Jackie Wilson, native Detroiter Bill Haley, and Wilson Pickett.

AUTOMOBILES

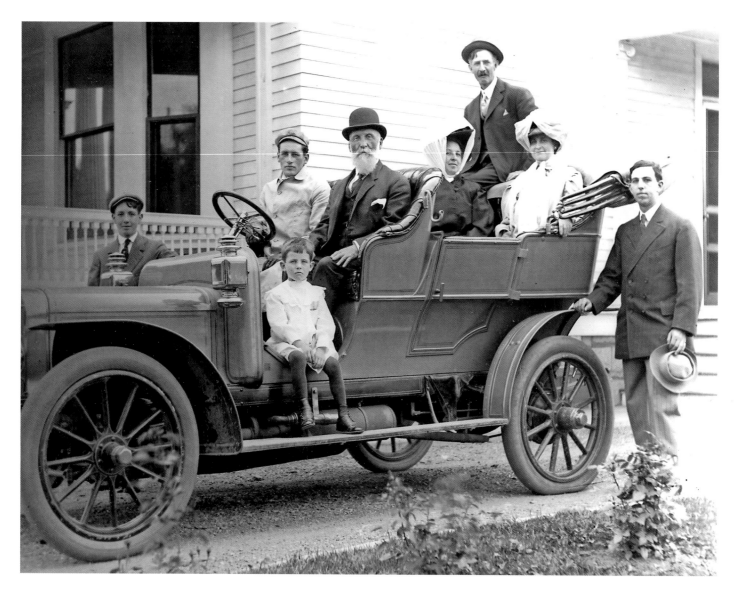

Above: *The family automobile, circa 1910.* Superior View

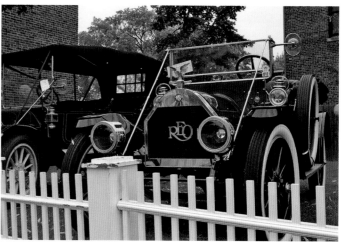

Right: *REO automobile produced by Ransom E. Olds*

From the Model T to the muscle car to the minivan, Michigan has served as the hub of the automobile industry since the turn of the twentieth century. The automobile was not invented in Michigan, nor were the first cars produced here, but the automobile *industry* was born and raised here. Through the ingenuity and drive of a few Midwestern inventors and entrepreneurs, the construction of gasoline-powered automobiles went from small-scale operations in local machine shops to one of the largest industries in the world. Many people played a part in this industrial leap of faith, but two men, Ransom E. Olds and Henry Ford, were instrumental in producing affordable automobiles for the use and enjoyment of America's growing middle class.

Ransom Olds is credited with designing the basic concept of the assembly line. At the Olds Motor Works in Detroit, he mass-produced the Curved Dash Oldsmobile, becoming the leading American auto producer from 1901 to 1904. Several years later, at his plant in Highland Park, Henry Ford perfected the process by installing a belt-driven assembly line and producing a whole Model T in ninety-three minutes. Ford paid workers an unheard-of wage: five dollars for an eight-hour workday. Through business savvy, the use of the assembly line, and the loyalty he inspired from his customers and workers, Henry Ford turned automobile production into one of America's largest industries.

The automobile continues to be a significant part of Michigan's heritage in the twenty-first century. The International Auto Show, classic cars shows, and the Woodward Dream Cruise showcase Michigan's past and present contributions to car culture. Although the majority of automobiles are now manufactured in places outside of Michigan, the industry is still one of Michigan's most vibrant and important businesses.

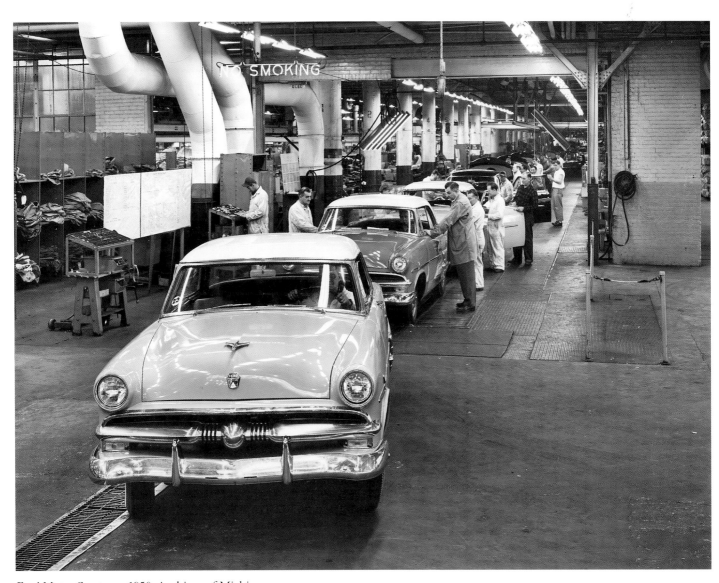

Ford Motor Company, 1950. Archives of Michigan

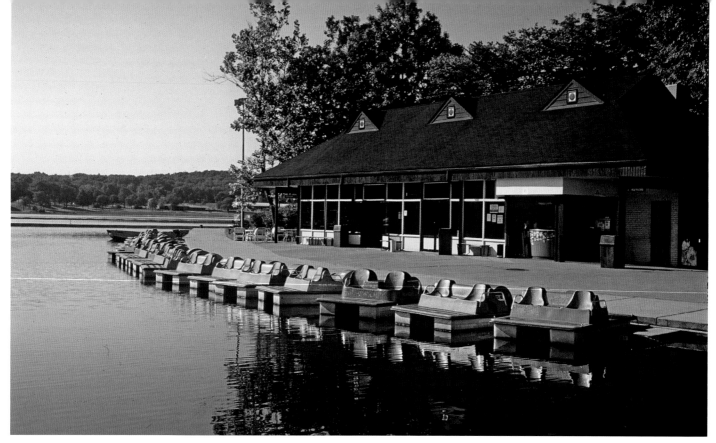

Kensington Metropark

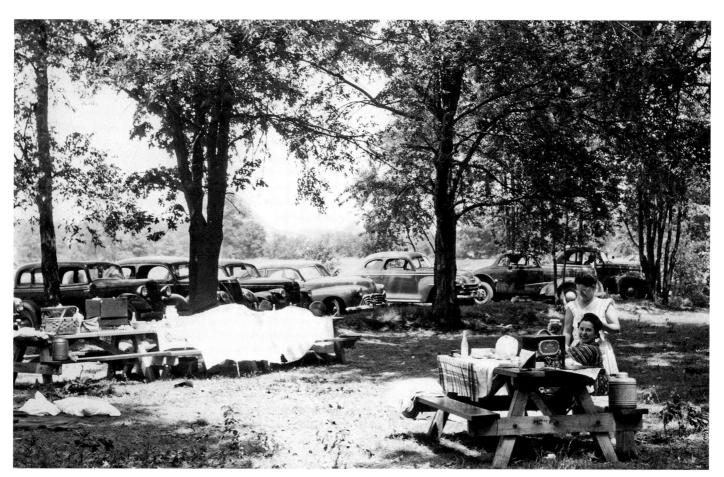

Weekend picnic at the park, 1948. Huron-Clinton Metroparks

A demonstration at Lake Erie Metropark by the Michigan Hawking Club

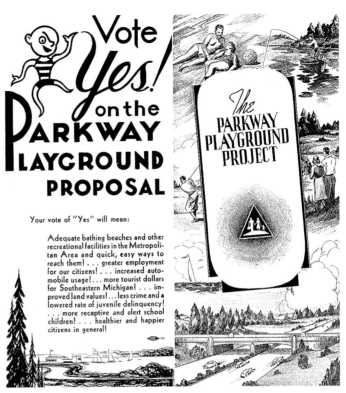

Brochure advertising the 1940 ballot initiative to create the Huron-Clinton Metropark system. Huron-Clinton Metroparks

HURON-CLINTON METROPARKS

Spread over five of southeast Michigan's most densely populated counties, the Huron-Clinton Metroparks provide an oasis of green around the sprawl of metropolitan Detroit. The concept of a metropark system took shape in the late 1930s when Detroit was growing by leaps and bounds and local public green space was becoming increasingly rare. The vision of two men, Dr. Henry Curtis and Professor Harlow Whittemore, ultimately led to the passage of a public act sanctioning the formation of the Huron-Clinton Metropark Authority.

Curtis and Whittemore foresaw the need for more park space in Detroit's densely populated Wayne County, a county that had a large tax base to support such a project but a limited amount of open space for a park. The surrounding counties were, at the time, less densely populated and had plenty of space for a new park system, but they had a limited tax base to support the project. By incorporating all five counties in the park scheme, the land and the money for the parks would benefit everyone in the region.

When funding for the acquisition of land became available in 1942, most of the lakefront property around southeast Michigan was already in private hands. The Metropark Authority looked instead to the river valleys of the Huron and Clinton rivers to purchase property for the new park system. The first property set aside was near Milford in Oakland County at the headwaters of the Huron River. Kensington Metropark was opened to the public in 1948, becoming the first Huron-Clinton Metropark.

Today, thirteen Metroparks encompassing more than 24,000 acres provide outdoor recreational opportunities for 9 million visitors each year. Bikers and joggers enjoy miles of well-maintained trails, and boaters and fishermen cruise the waters of small lakes like Kent Lake or the open waters of Lakes St. Clair and Erie. Every Metropark has picnic facilities and many offer swimming beaches, nature trails, golf, cross-country skiing, and ice skating. The larger parks such as Metro Beach, Stony Creek, and Kensington are often crowded, but the smaller parks, such as Delhi or Dexter-Huron, are a great place to escape the crowds and enjoy a quiet day surrounded by nature.

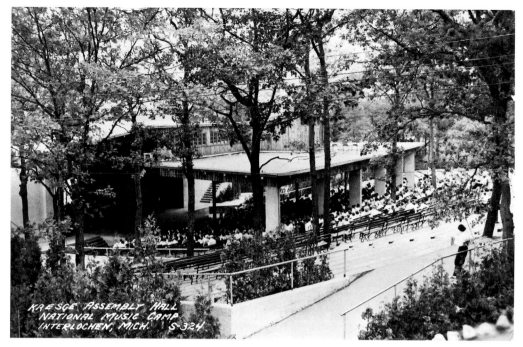

Live performance at Interlochen, circa 1960. Voyageur Press archives

INTERLOCHEN CENTER FOR THE ARTS

Growing from the vision of a high-school orchestra leader into America's largest youth center for the arts, Interlochen has surpassed the wildest dreams of its humble founder. During the past eighty-odd summers, the ancient pines that tower over the campus have seen more than 85,000 students of the creative arts expand their artistic horizons. Interlochen has become synonymous with fine art, especially musical performance, and draws teachers and performers from the elites of the classical arts.

Founded in 1928 by Dr. Joseph Maddy as the National High School Orchestra Camp, Interlochen soon outstripped its original scope and, in only three years, became the National Music Camp. The camp's affiliation with the University of Michigan School of Music in 1942 cemented its reputation as the country's premier summer music camp. Guest performers and teachers at the camp have included conductor Eugene Ormandy, violinist Itzhak Perlman, and composer Aaron Copland.

In 1960, the Interlochen Arts Academy opened its doors. The boarding school has since distinguished itself by graduating more Presidential Scholars in the Arts and Academics than any other high school in the United States. College-bound artists at the school follow a rigorous college-prep curriculum that includes intensive, specialized training in the fine arts.

Alumni from the academy and the music camp account for 10 percent of the musicians in America's major orchestras and have distinguished themselves as professional actors, writers, dancers, and visual artists. Many familiar people in journalism like Mike Wallace and David Blum attended Interlochen, as did pop and classical singer Josh Groban and Google cofounder Lawrence Page.

Tucked away among the towering pines of Interlochen's 1,200 acres are dozens of natural stone and wood practice studios and two performance stages: the Interlochen Bowl and the Kresge Auditorium. On any given day you might hear the words of a Shakespeare play, the strains of a Bach cello suite, or a future operatic voice ringing in the air. In recent years, Interlochen has expanded its mission to include training for painters, poets, sculptors, dancers, and other expressions of the fine arts.

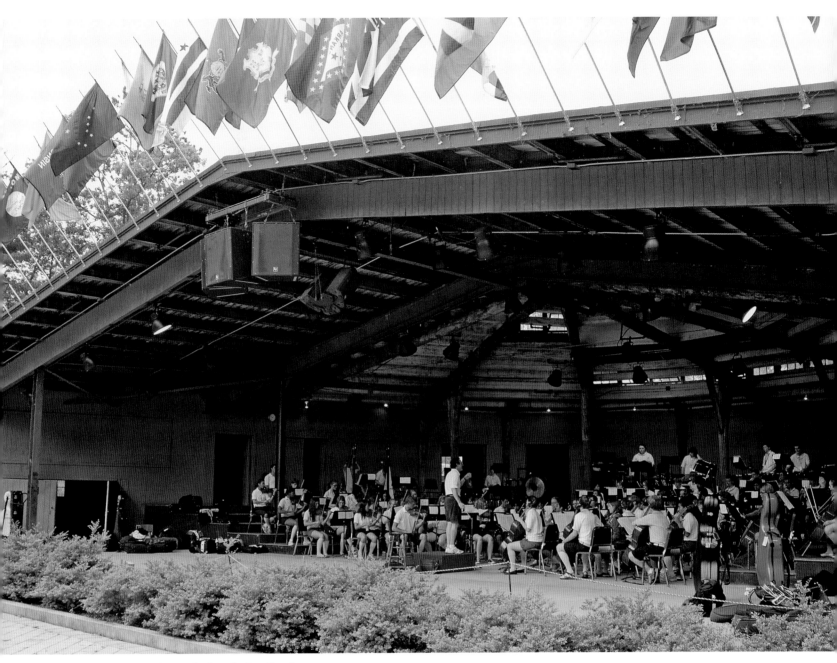

Students practicing at the Interlochen Bowl

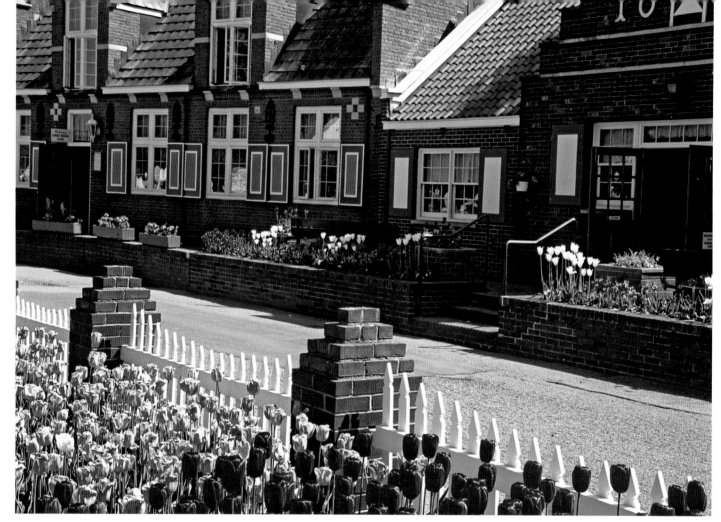

The Dutch Village on Windmill Island

HOLLAND TULIP TIME FESTIVAL

Holland in May means wooden shoes and windmills, blue and white Delft pottery, and acres of lipstick-bright tulips. Each spring, more than one million tourists come from all over North America to bask in the sunshine and enjoy parades, music, Dutch culture, and millions of blooming tulips—making the Holland Tulip Time Festival one of America's premier small-town festivals.

Holland's tulip craze traces its roots to 1927, when Lida Rogers, a biology teacher at the local high school, suggested that Hollanders plant tulips around town to brighten up their city. With the city pitching in 100,000 bulbs, Hollanders planted the flowers, and by the spring of 1929, the city was awash in bright tulips. In May 1930, the first Tulip Festival was organized.

As the number of blooming tulips increased, so did the number of people attending. The first Tulip Festival in 1930 drew around fifty thousand people; that number more than tripled the following year. Over the years, Klompen dancing and other folk activities have added a touch of Dutch culture to the festivities.

One of the festival's premier attractions is the De Zwaan windmill, an authentic eighteenth-century Dutch windmill brought to Holland from the Netherlands in 1964. The twelve-story-high windmill serves as the centerpiece of Windmill Island, an island park near downtown Holland. The park features an authentic Dutch village where visitors can purchase Delftware, wooden shoes, hand-carved wax candles, and a host of craft items. More than 100,000 tulips bloom each spring around the windmill and village. Windmill Park is also the home of a genuine Amsterdam street organ that provides music for a company of Klompen dancers.

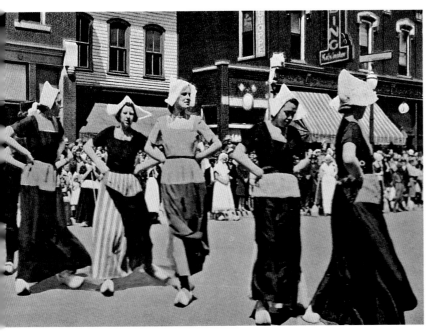

Dutch folk dancers. Voyageur Press archives

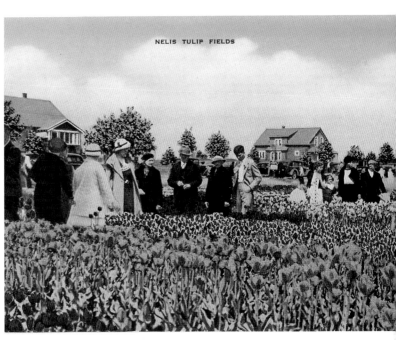

Festival-goers from the 1940s. Voyageur Press archives

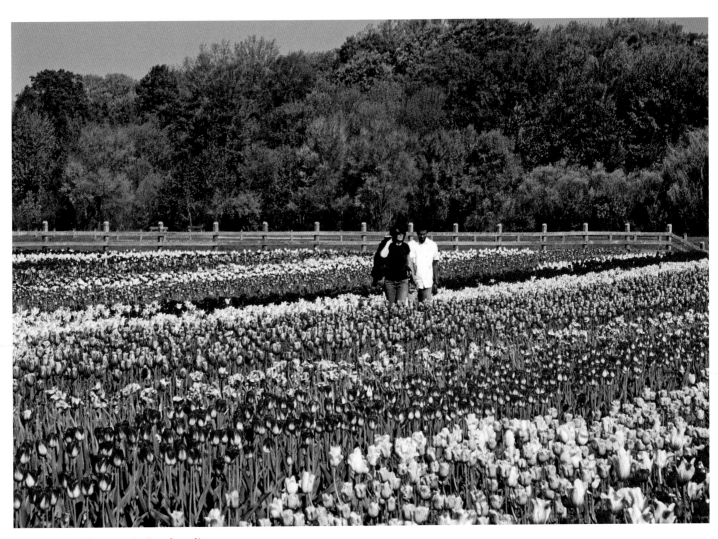

Modern festival-goers enjoying the tulips

TIP-UP TOWN USA

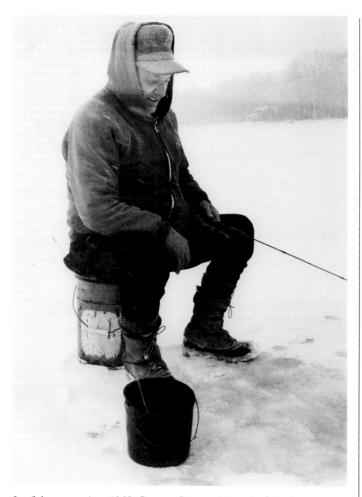

Ice fisherman, circa 1960. Otsego County Historical Society

Tip-Up Town USA celebrates a pastime that is viewed by many (especially those from warmer climates) as being slightly crazy. But since 1951, thousands of enthusiasts have met each year in the dead of winter on a frozen lake to revel in the sport of ice fishing. What started as a winter festival designed to bring off-season tourists to Houghton Lake now draws upwards of eighty thousand people to Michigan's largest inland lake during the last two weekends in January. In addition to the traditional fishing contests, the festival now features a parade, ice sculptures, softball on ice, and a treasure hunt, and it tops off the event with a fireworks display over the frozen lake.

For those not familiar with ice-fishing terminology, Tip-Up Town USA got its name from the ice-fishing device called a tip-up. Instead of drilling a single hole in the ice and sitting over it with a miniature fishing pole waiting for the big one to take

your bait, the tip-up fisherman drills a number of holes spread over his favorite spot and sets a "tip up" over each hole. The tip-up is a wooden or metal frame that straddles the hole in the ice and holds a spool of line attached to a trigger device with a flag. When a fish takes the bait, the flag springs into the air and the fisherman springs into action, rushing over to set the hook and haul in his trophy. With the tip-up, the fisherman can spend his time on the ice playing cards or shooting the breeze rather than staring into a hole in the ice.

The annual festival has become a winter tradition, with many families returning to Tip-Up Town USA year after year. To enjoy all that the festival has to offer, visitors purchase a badge that admits them to the events and helps finance the festival. In the early days, these badges were wooden; later versions were metal. The old badges have become collector's items for long-time patrons of the festival.

Carnival midway at Tip-Up Town USA

Winter softball on the ice

FRANKENMUTH

The Bavarian settlers called their new home Frankenmuth, meaning the "courage of the Franconians." Founded as an experimental mission congregation, the settlement's original fifteen colonists arrived at New York City in 1845 after a harrowing fifty-day journey across the Atlantic through violent storms and encounters with icebergs, smallpox, seasickness, and inedible provisions, followed by an equally disaster-filled trip by rail and steamer to Bay City. The final leg of the journey, through twelve miles of Michigan swamp, thicket, and uncleared forest, brought the exhausted yet resolute colonists to their new home along the banks of the Cass River.

The colonists brought with them their tradition of Bavarian dress, social structure, and commitment to German Lutheranism. At the onset, the colonists pledged loyalty to Germany and promised to retain their mother language in an exclusively German colony. As with other ethnic enclaves established in Michigan in the nineteenth century, the colony gradually tempered its isolationist ideals over time and became a part of the new American culture.

For the beer-drinking Germans of Frankenmuth, the Prohibition era was one of the town's most challenging times. Despite the law, local establishments continued to serve homemade beer to townsfolk and visitors. Federal agents from Detroit raided two of the town's landmark hotels, Zehnder's and Fischer's, and charged the owners with bootlegging. Despite their lofty standing in the community, both men received large fines that nearly put them out of business; but through it all, they retained the support and sympathy of the town's citizenry.

Many fine Bavarian-German traditions remain in Frankenmuth in the twenty-first century, and the town's Old World flavor and famous hospitality draw tourists year-round. Frankenmuth is home to Bronner's CHRISTmas Wonderland, the largest Christmas store in the world, and Zehnder's and the Bavarian Inn (formerly Fischer's Hotel) serve their famous Sunday-style chicken dinners to thousands of visitors from around the world.

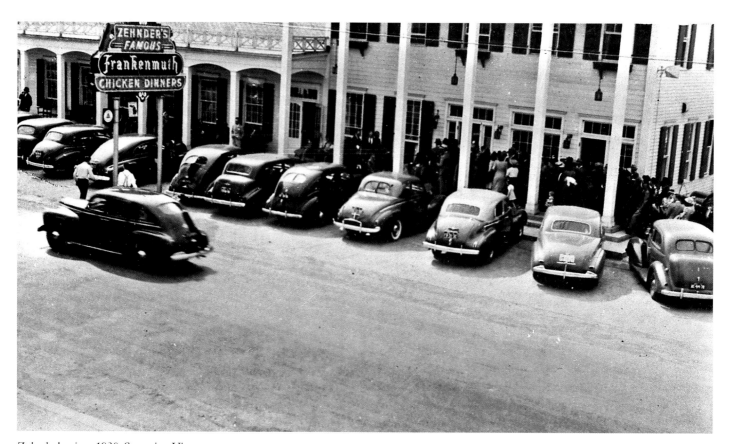

Zehnder's, circa 1930. Superior View

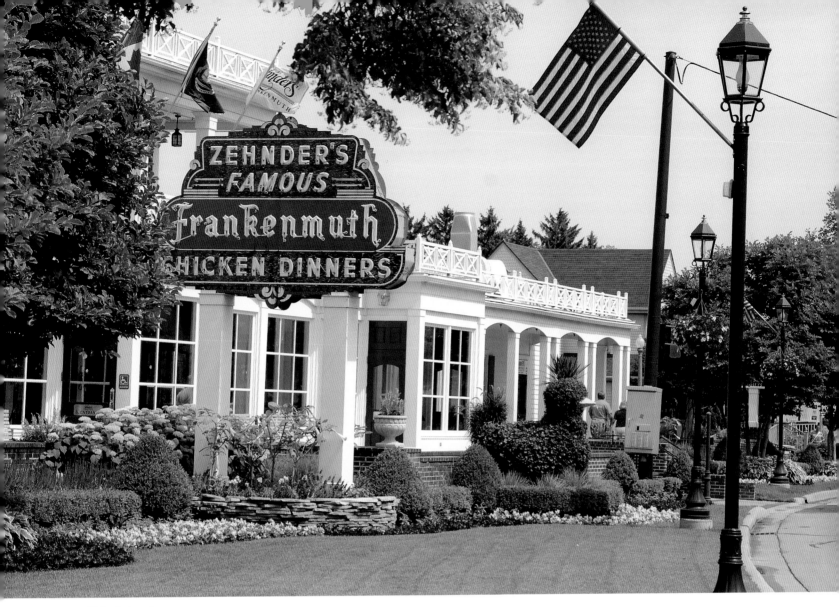

Zehnder's today

The Bavarian village

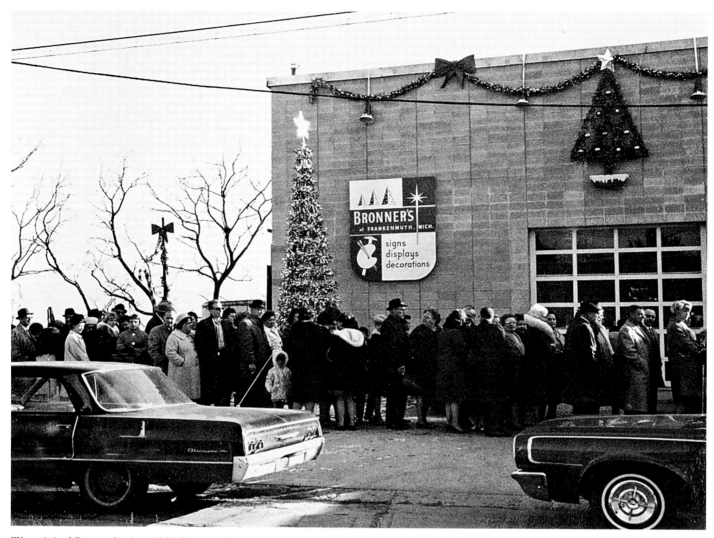

The original Bronner's, circa 1960. Bronner's

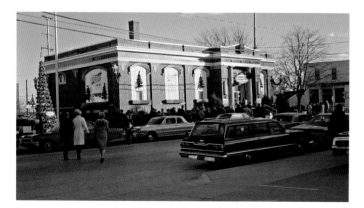

Bronner's, 1970. Bronner's

Bronner's today

Bronner's CHRISTmas Wonderland

As long as people can remember, billboards across Michigan have touted Christmas year-round at Bronner's CHRISTmas Wonderland in Frankenmuth. In fact, drivers heading north on Interstate 75 near Ocala, Florida, pass the farthest of sixty billboards scattered across seven states. In a little over fifty years, Bronner's has evolved from a small sign-painting and window-design business to the largest Christmas store in the world. Today, more than 2 million people visit Bronner's each year, including more than two thousand motor-coach tour buses.

Wally Bronner began selling Christmas decorations from a small building in downtown Frankenmuth in 1954. Nine years later, he expanded the building to accommodate his growing business. By the early 1970s, Bronner owned three stores in Frankenmuth and had so many customers during the holidays that long lines and traffic congestion became a problem for the small village. In 1977, Bronner moved his stores to a 45-acre site on Frankenmuth's south side and Bronner's CHRISTmas Wonderland was born.

Bronner's current building covers 7.35 acres, including a 2.2-acre showroom packed with Christmas decorations of every description. Each evening year-round, 100,000 Christmas lights illuminate 27 acres of landscaped grounds surrounding the building. The grounds feature decorated lampposts, a life-size nativity scene, three 17-foot-tall replicas of St. Nick, and a towering snowman.

Bronner's sells over 1.3 million ornaments each year.

SENEY NATIONAL WILDLIFE REFUGE

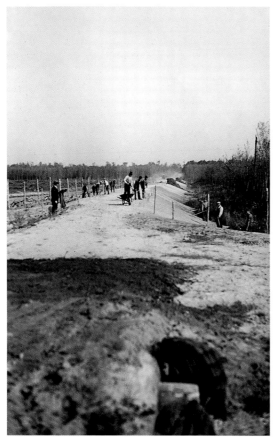

CCC workers building dikes in Seney NWR, circa 1935.
U.S. Fish and Wildlife Service

The timber was gone, cut up and sent floating down the Manistique River to the mills on Lake Michigan. Gone, too, were the logging crews, moved on to new stands of virgin timber in western Michigan and Wisconsin. In their wake, the landscape around the town of Seney lay in a ruin of logging slash, tree stumps, and sawdust—and then came the fires. When the last of the dried litter of the logging operations had burned, the land was subdivided, drained, and sold to unwary settlers who found that crops would not grow in the cold, shallow, acidic soil. In a few short years, the land around Seney had become worthless to people and to the wildlife that once flourished there.

The rebirth of Seney began during the Great Depression. Crews from the Civilian Conservation Corps set up camp nearby and began to reshape the battered landscape. In what may have been the first large-scale environmental engineering project of its kind, the CCC engineered a series of dikes and ditches to create twenty-one large, shallow ponds that formed over seven thousand acres of open water.

Roads were built to access the ponds, and wild grasses were planted in the hopes of drawing waterfowl back to nest and raise their young. The Seney National Wildlife Refuge is now home to nearly two hundred species of bird, including bald eagles, loons, and the world's largest aquatic bird, the trumpeter swan. The birds share the 95,455-acre refuge with a large variety of mammals like black bears, gray wolves, white-tailed deer, beavers, and otters as well as twenty-six different species of fish.

A narrow but well-maintained gravel road passes through the eastern portion of the refuge, leading visitors alongside open pools, wet meadows, and forest land. Along the way, you can easily spot wildlife from the window of your vehicle or get a closer look through strategically placed telescopes on one of the refuge's wildlife observation decks. The many hiking and cross-country ski trails offer an extra bit of solitude and a chance to view wildlife up close.

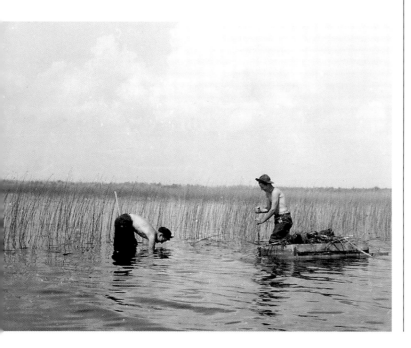

CCC crews planting wild rice in Seney NWR, circa 1935. U.S. Fish and Wildlife Service

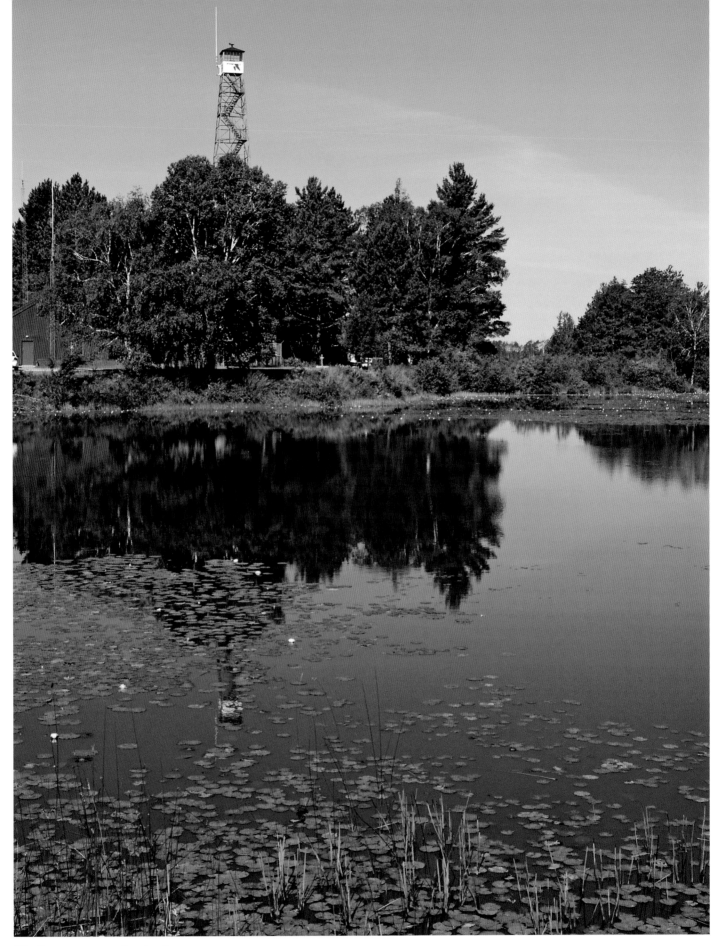

The fire tower near refuge headquarters

MACKINAW CITY

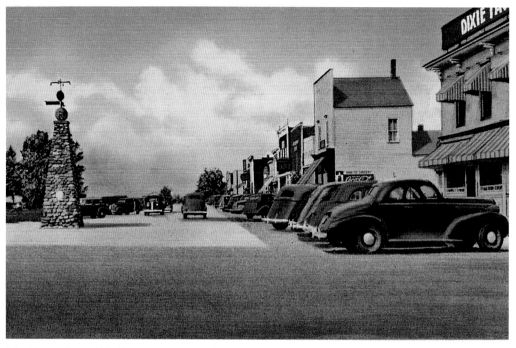

Mackinaw City, 1938. Voyageur Press archives

Mackinaw City was platted in the 1850s, some 220 years after the first European, Jean Nicolet, passed by on his quest to discover a northwest passage to the Orient. Between the time of Nicolet's passage and the city's founding, the area around Mackinaw City had become the focal point of trade and military conflict in the upper Great Lakes. By the mid-nineteenth century, timber harvest and mining were driving Michigan's young economy and the northernmost point in the state's Lower Peninsula promised to be an important link in transportation and trade. It wasn't until the late nineteenth century, however, when a ferry service linked the railroads across the Straits of Mackinac, that Mackinaw City realized its full potential as a vital cog in Michigan's transportation network. Ferryboats carried railroad cars across the Straits until 1984, when truck service over the Mackinac Bridge made rail service obsolete.

Mackinaw City later realized its tourism potential in the early twentieth century. As state roads spread north to the Straits and across the Upper Peninsula, travelers began to stack up at Mackinaw City, waiting to make the ferry crossing to St. Ignace. Mackinaw City also became a major gateway to Mackinac Island when several companies began offering passenger ferry service to the island. Today, the city is a tourist destination in itself with plenty of opportunities for shopping, dining, and water sports. And, of course, there is the city's world-famous fudge.

Capitalizing on the near constant winds that blow across the Straits of Mackinac, the city invested in two wind turbines, installing them just south of town. The twin turbines, which are visible from Interstate 75, stand 320 feet tall to the tip of the blade. Each turbine provides enough electricity to power about 330 homes for a year. The blades spin at either 14 or 22 revolutions per minute, depending on conditions, and the tip of the blade can travel as fast as one hundred miles per hour.

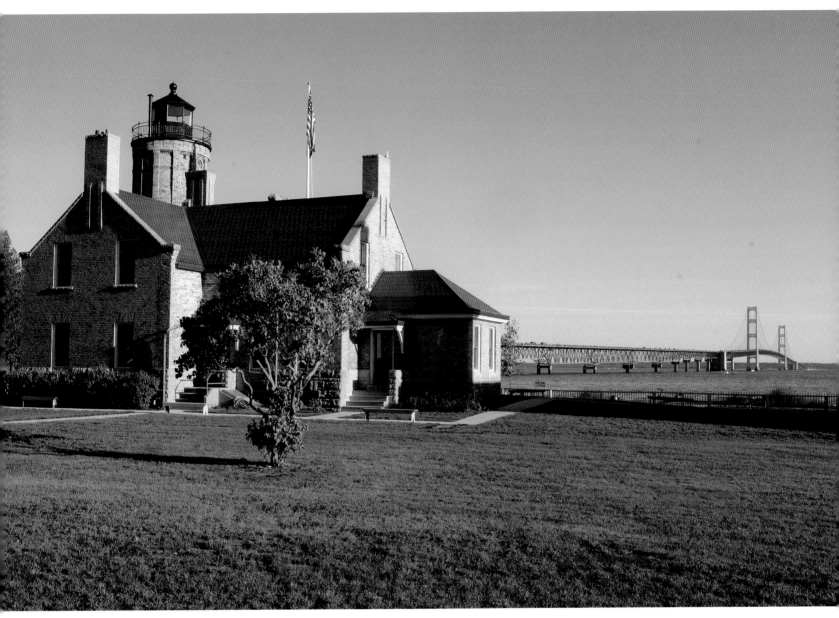

The Old Mackinac Point Lighthouse

Downtown Mackinaw City and its famous fudge shops

THE BEACH

The UP's Lake Michigamme, circa 1940. Superior View

With more than three thousand miles of Great Lakes shoreline and eleven thousand large and small inland lakes, Michigan boasts a wealth of sandy beaches. For city and suburb dwellers, summer vacation means going to the lake, and going to the lake means spending time on the beach. Michigan's highway system has made the beach accessible to just about anyone with a summer afternoon to kill. The most popular sites overflow with swimmers and sun-tanners, but if you take the time to look, you can still easily find a quiet spot on the warm sand.

In the mid-nineteenth century, families who could afford to escape the heat of the city boarded a train or steamship bound for the shores of Lake Michigan. The eastern shore contains the world's largest freshwater dune system and some of the finest beaches anywhere. From South Haven to Mackinac, summer homes and cottages sprang up along the waterfront, giving rise to a tradition of beach vacationing that continues today. Many of the finest beaches along Lake Michigan, like Holland, Grand Haven, and Petoskey, are now included in Michigan's state park system.

With all those vacation homes, Lake Michigan can get a little crowded for some people's tastes. For beachgoers who prefer lying in the sand listening to the whisper of the wind through the pine trees, Michigan's inland lakes offer a more secluded experience. Most of Michigan's larger inland lakes include at least one public swimming beach and many, like Higgins Lake near Roscommon, are home to fine campgrounds. During the Depression years, the Civilian Conservation Corps constructed many of the facilities found at the state's more popular beaches. The Corps was also instrumental in restoration and stabilization efforts at many beaches after the devastation caused by clear-cut logging during the late nineteenth century.

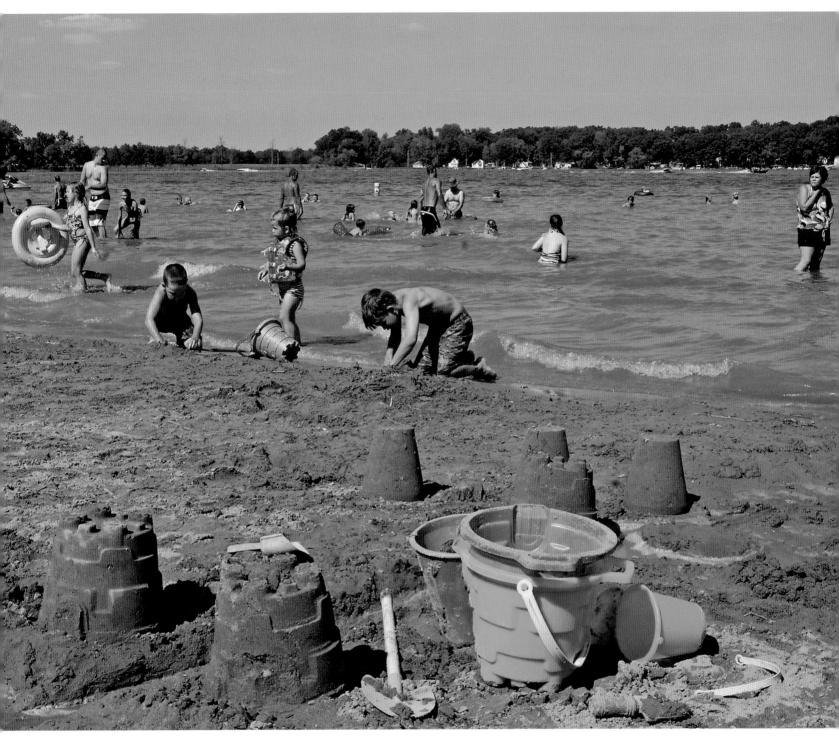

Portage Lake in the Waterloo Recreation Area

The Eastern Market, circa 1970. Superior View

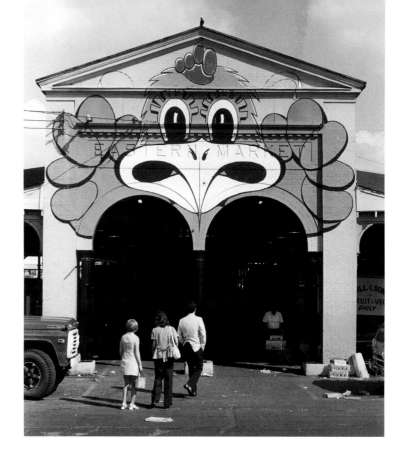

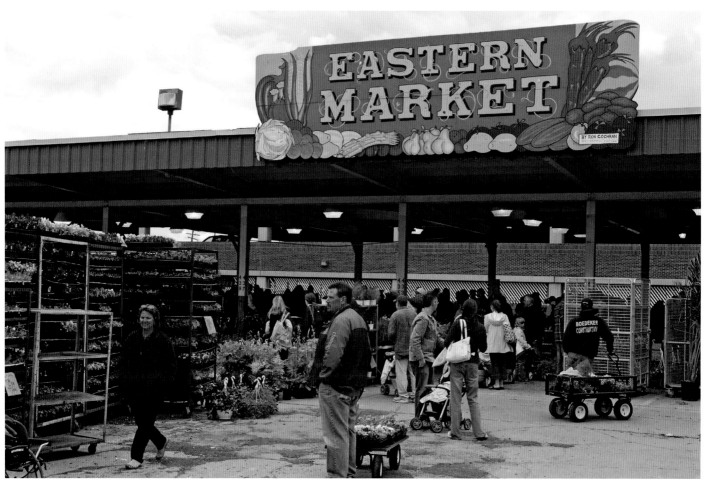

The Eastern Market today

THE EASTERN MARKET

From its humble beginnings as a collection of open stalls and sheds in downtown Detroit, the Eastern Market has grown into the largest historic public market district in the United States. It began in the old Cadillac Square area in 1841 as an open-air market featuring foods produced by local farms. The Eastern Market has occupied its current site between Mack and Gratiot, west of St. Aubin Street, since 1891, when crowding and high real estate prices drove it out of downtown. In the early days, the Eastern Market competed with two other outdoor markets in Detroit, the Western Market and the Chene-Ferry Market. Both rivals have since closed, leaving the forty-three-acre Eastern Market to thrive.

The Eastern Market quickly grew to include restaurants, meat markets, and specialty shops. Detroit's famous Stroh's Brewery was located just south of the market, and two historic German churches, one Catholic and one Lutheran, served the large German population in the area. The popularity of the market with the public quickly grew, and by the 1940s, the market was selling record amounts of produce, meat, and beverages.

When the population of Michigan began to turn to supermarket shopping and pre-packaged foods in the 1950s, the Eastern Market responded by becoming Detroit's main food distribution center. Despite the radical changes in America's eating habits, the Eastern Market continued to supply shoppers with fresh fruits, vegetables, and meat.

The Eastern Market was designated a Historic Site by the Michigan Historical Commission in 1977. Many of the original buildings still house businesses today, and many of the merchants at the market have operated there for generations. The market still draws crowds of shoppers each Saturday and supplies fresh food to local retailers on weekdays. The annual Flower Day at the market draws record crowds each spring as Detroiters and visitors stock up on flats of vegetables and flowers for the garden.

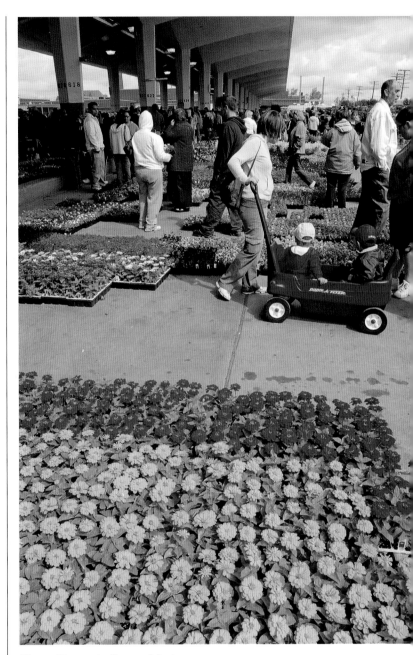

Flower Day at the Eastern Market

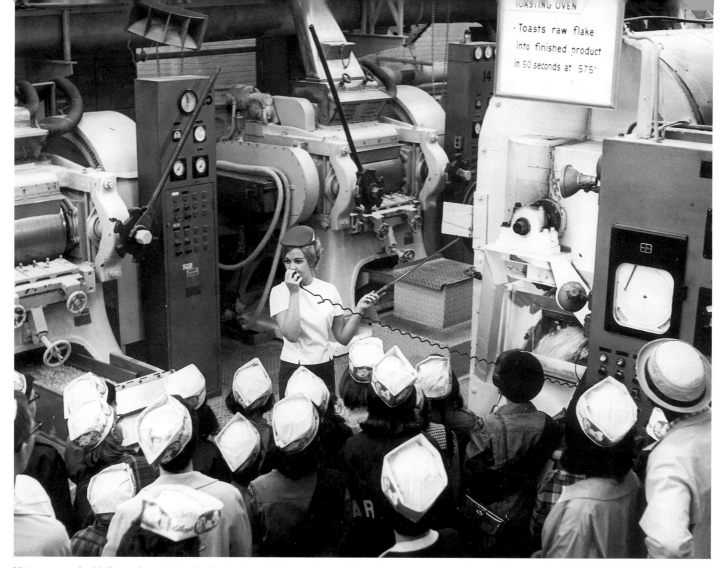

Visitors tour the Kellogg plant in Battle Creek, circa 1965. Archives of Michigan

Pasty sign

FOOD

The settlement years of the early nineteenth century saw a tremendous influx of European immigrants, drawn to Michigan to harvest timber, mine copper and iron ore, and farm the land. Along with their hopes and dreams for a better future, these settlers brought with them the traditions of religious practice, culture, and culinary art from their homeland. At first, the settlers lived in tightly knit ethnic enclaves, but as cultural barriers broke down, the individual enclaves began to open up to outsiders. This created a smorgasbord of culinary choices that would have been impossible for the new immigrants to experience in their native land.

From Bavarian enclaves in Frankenmuth and Detroit came beer and bratwurst; from Hamtramck, Polish sausage and stuffed cabbage. In the far reaches of northern Michigan, Cornish miners introduced the pasty: a portable, hot, and hearty meat pastry perfectly suited to Michigan's sometimes harsh climate. Restaurants sprang up in ethnic enclaves in cities from Marquette to Grand Rapids to serve local tastes and, later, to serve visitors who had a taste for international cuisine.

Many Michigan food producers and breweries began as local, family-operated businesses and have gone on to become internationally known companies. The Feigerson brothers (Faygo) and James Vernor brought soda pop to the world, and Bernhard Stroh introduced the world to fire-brewed Bohemian beer. W. K. Kellogg introduced the United States and the world to Corn Flakes and established Battle Creek as the cereal capital of the world. Detroit confectioner Fred Sanders sold the world's first ice cream soda out of his shop on Woodward Avenue in the 1920s, and when it comes to sweets, what Michigander can say Mackinac without saying fudge?

Greektown, a popular Detroit dining destination

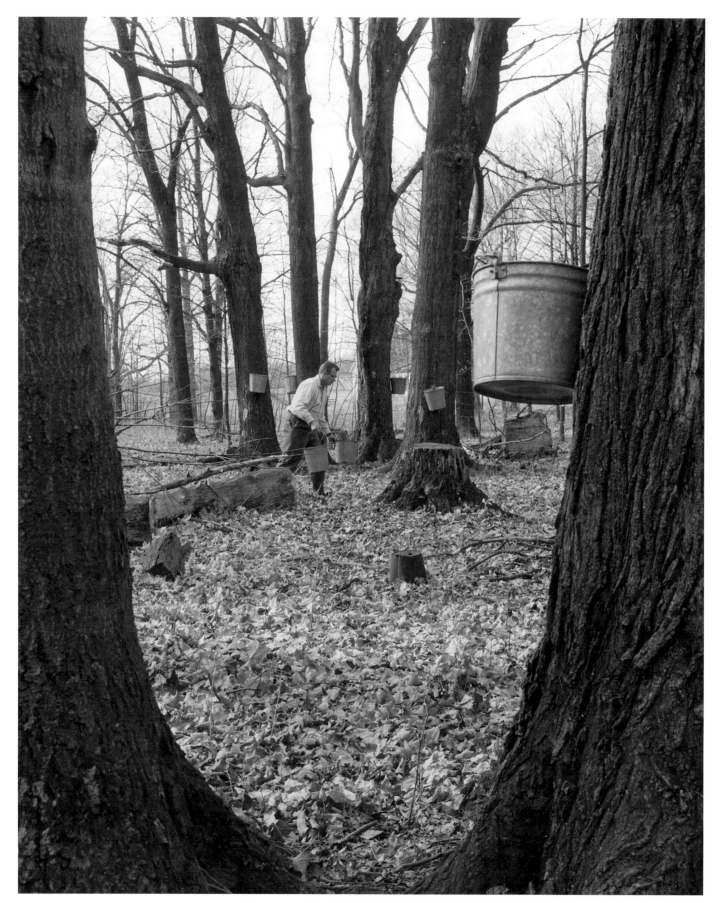

Collecting sap, circa 1965. Archives of Michigan

VERMONTVILLE MAPLE SYRUP FESTIVAL

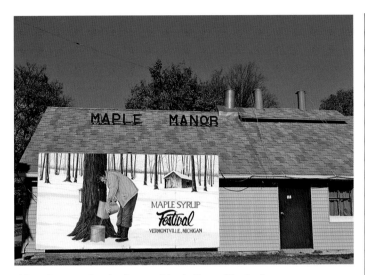

Advertisement for the famous Maple Syrup Festival

After only six years, the festival was attracting more than ten thousand people and the village's yearly production of maple syrup was being bought up in the first half hour of the festival. As the festival grew, so did the amount of syrup produced by local families. About ten local syrup producers now boil and bottle all the maple syrup sold during the festival. The last weekend of April marks the beginning of the festivities, which now include a craft show, pancake breakfasts (featuring Vermontville maple syrup, of course), and a host of other family activities.

I t is March in mid-Michigan and, despite the patches of snow that remain on the ground deep in the woodlots, spring is in the air. The evening light lasts longer this time of year, but the air is still chilled and the water-saturated ground gives way beneath your feet when you step. If you look closely at the red buds of the sugar maple trees, you will notice that they have begun to unclench from their tight winter fist. The sugary sap stored in the roots of the maples has begun to move up the tree trunk to fuel the tree's annual wakeup from hibernation. In Vermontville, it is time to collect the free-flowing sugar water and begin the age-old process of making maple syrup.

The practice of "sugaring," or making sugar or syrup from the sap of maple trees, has been a part of springtime in Michigan since the days of the Woodland Indian people. After a winter spent in relative isolation on their family's winter hunting grounds, the tribe members would come together at a sugaring encampment each spring. Using kettles made of birch bark, Native Americans rendered the maple sap until it crystallized into sugar. Later, the practice of making maple sugar was taken up by settlers who also enjoyed the unique taste.

The village of Vermontville, with its abundance of maple trees, is a natural for a celebration of maple syrup. In 1940, Milton Lamb suggested to his fellow patrons at the local barbershop that a festival would bring in customers for local syrup producers and other businesses. The other patrons agreed, and the Vermontville Maple Syrup Festival was born.

Vermontville's breathtaking maple trees

Agriculture

An early motorized tractor pulls a load of peppermint, 1906.
Archives of Michigan

They came from all over Europe for a chance to own land and plant the soil, but most of Michigan's land did not yield easily to the plow. Even after the loggers had removed most of the original forests, would-be farmers who came to the northern reaches of the state found sandy, nutrient-poor soil and a short growing season. In the south, in what is now Michigan's farm belt, the soil was more amenable to growing crops, but not before land was cleared and, in many cases, after ditches and drains were dug to lower the water table. Early farmers faced fire and flood, drought, frost, and backbreaking work; but in the end they succeeded in making the state an agricultural giant.

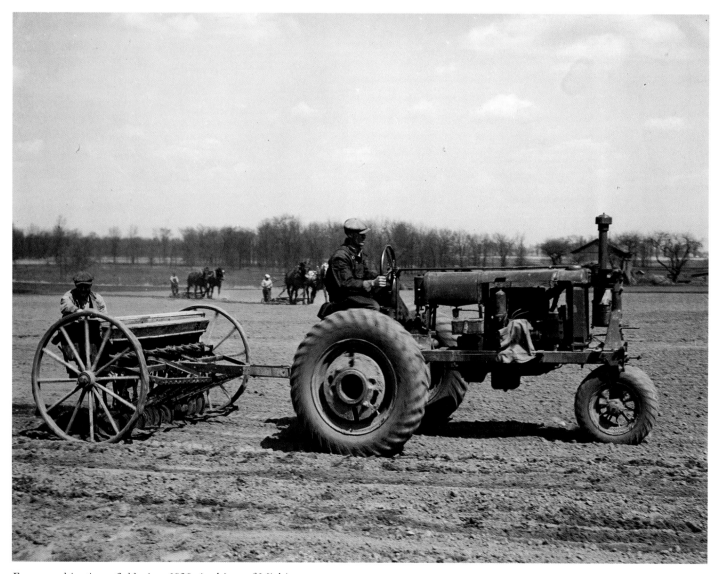

Farmer cultivating a field, circa 1920. Archives of Michigan

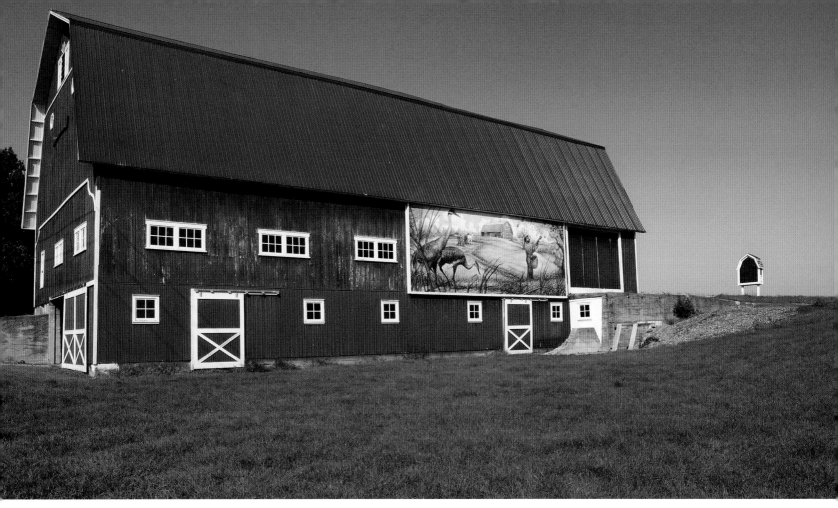

A family farm

Roadside market

Michigan's agricultural products are as diverse as its landscape. The state's leading farming counties lie in the rich plains at the tip of the thumb and the sandy loam of the southwest portion of the Lower Peninsula. In Huron and Sanilac counties in Michigan's thumb, corn, navy beans, sugar beets, and grain thrive on the tabletop-flat land. The gently rolling hills of western Michigan are ideal for raising many types of fruits and vegetables. Western Michigan leads the country in the production of blueberries and tart cherries and is a leading producer of apples, sweet cherries, and asparagus. Rounding out the Michigan cornucopia are soybeans, dairy, cattle, corn, and greenhouse plants.

The best way to enjoy Michigan's agricultural bounty is to visit a roadside produce stand at the height of the harvest season. In late summer, sweet corn, peaches, plums, pears, and tomatoes sell by the bushel, peck, or bagful along country roads. As autumn approaches, the wooden bins at the roadside stands overflow with a dozen varieties of apples, pumpkins, grapes, and squash. Autumn also heralds county fair season and the yearly competition for the biggest and tastiest fruits and vegetables.

Farming has always been a hardscrabble business, but the rewards it offers have kept generations of Michigan farmers happily tied to their land. There are 53,000 farms operating in Michigan, and over 90 percent are family-owned. With an average size of two hundred acres, Michigan's small farms help to add over $4 billion annually to the state's economy.

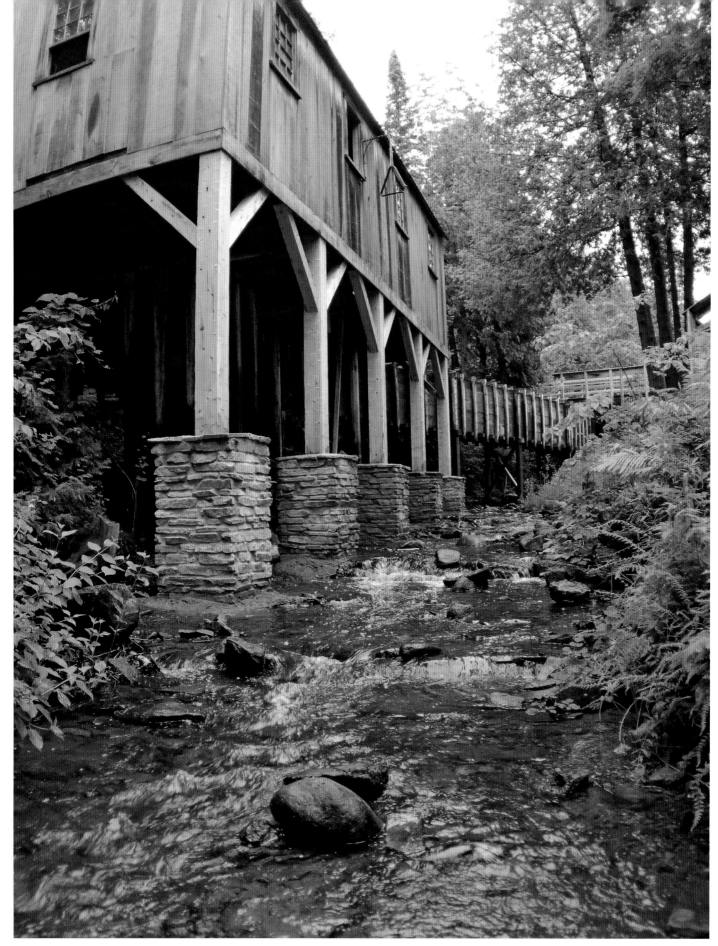

Historic Mill Creek near Mackinaw City

WATER-POWERED MILLS

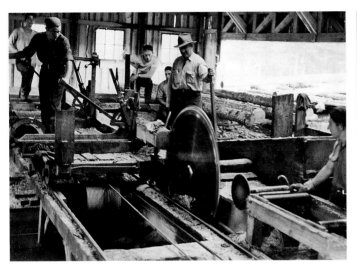

Portable mills cut raw timber for local building projects, circa 1935. U.S. Fish and Wildlife Service

In the years following statehood, as the population of Michigan swelled with displaced New England Yankees and European immigrants, the wholesale exploitation of Michigan's natural resources began. During the winter, in the deep forests of Michigan's interior, lumberjacks cut old-growth white pine at a frantic pace while teamsters moved the raw lumber on horse-drawn sledges to the banks of Michigan's rivers. When winter released its grip, great rafts of logs were floated downstream to the coast, where water-powered sawmills cut the raw timber into dimension lumber. The lumber from Michigan's sawmills built the nineteenth-century towns and cities of the American Midwest.

At the mouth of Michigan's great inland waterways, like the Grand, Manistee, Muskegon, and AuSable rivers, and at countless smaller rivers and tributaries, water-powered sawmills employed thousands of workers. As Michigan's agriculture expanded, water-driven gristmills began turning raw corn and grain into flour. So important were mills to early settlement towns that the construction of a mill often preceded schools, churches, and even roads. The mill served as the center of commerce in many towns, creating an atmosphere of economic growth around which satellite industries such as the blacksmith, general store, and granary sprang up. Mills also functioned as a meeting place and social center for many communities.

The technology and mechanics of the water-driven mill laid the foundation for further advances in automation. As the demand grew for water-powered machinery to become quicker and more efficient, the process of building and maintaining machinery became more refined. This refinement of water mills led to advancements in many other technologies of the time and spilled over into a host of other industries.

When the industrial revolution introduced steam-power technology to the United States at the end of the nineteenth century, the water-powered mill quickly became a thing of the past. Many of Michigan's original water mills have been renovated and restored and now serve as historical museums or the centerpiece of riverside parks, while others have been retrofitted to produce apple cider. In today's world of lightning-fast, energy-intensive, computer-driven machinery, the slow-driven, water-powered mill is a welcome respite.

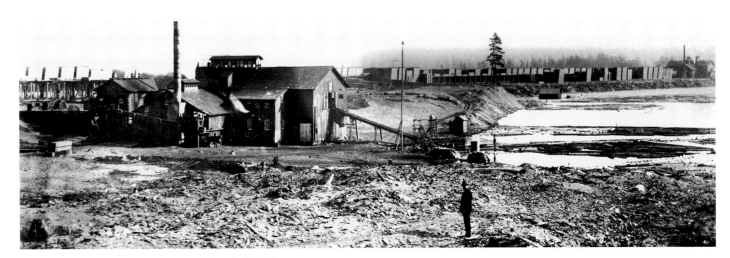

Lumber mill, 1890. Otsego County Historical Society

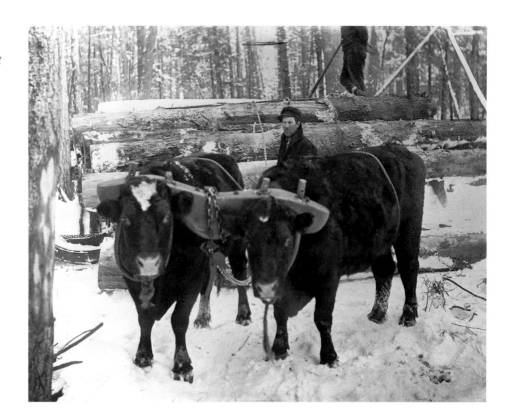

Bright Lake and Glory Lake in Hartwick Pines State Park were named for the logging company's oxen team, 1870. Superior View

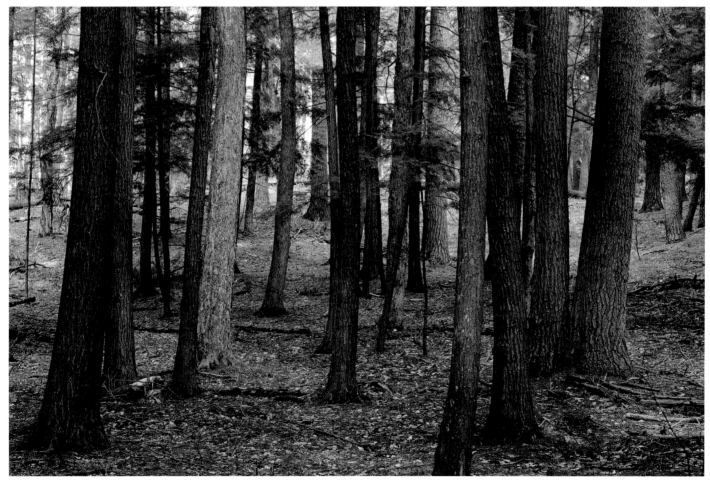

The Old Growth Forest

HARTWICK PINES

The Logging Museum

When Karen Michelson Hartwick purchased eight thousand acres of logged-over land near Grayling in 1927, the commercial value of the property was questionable. But the land contained a rare treasure: Nestled in the midst of the property was eighty-five acres of virgin, old-growth white pine forest. The old-growth forests of Michigan had long since disappeared under the relentless steel teeth of the whipsaw and the finely honed axe. Somehow, this small copse of large trees had survived the onslaught that had felled nearly every other old tree in Michigan's Lower Peninsula.

Karen Hartwick was no stranger to the logging industry. Nels Michelson, her father, had been a founding partner of a logging company that had cleared the forests around Grayling many years earlier. Soon after purchasing the property, Karen Hartwick donated the land to the State of Michigan as a memorial to her late husband, Edward Hartwick, who had died overseas during the First World War. Mrs. Hartwick also requested that a museum be built on the property to commemorate the logging industry,

and in 1935, the Civilian Conservation Corps completed two log structures to house the museum. The log buildings serve as the centerpieces of the Hartwick Pines Logging Museum, a collection of restored logging equipment and displays that illuminate life in a nineteenth-century logging camp.

At nearly ten thousand acres, Hartwick Pines State Park is the largest state park in Michigan's Lower Peninsula. At the center of the park, the Hartwick Pines Old Growth Forest Trail meanders through the remaining forty-nine acres of old-growth forest (twenty-six acres of the original old-growth was destroyed in a devastating windstorm in 1940). The park also features a modern campground and opportunities for hiking, mountain biking, cross-country skiing, wildlife viewing, and fishing on four small lakes or the east branch of the famous AuSable River. The Michigan Forests Visitors Center, the official interpretive center for the Michigan forest industry, sits at the entrance to the Old Growth Forest Trail. The center offers hands-on exhibits and a variety of programs dealing with Michigan forestry from the logging era to the present.

THE SUMMER COTTAGE

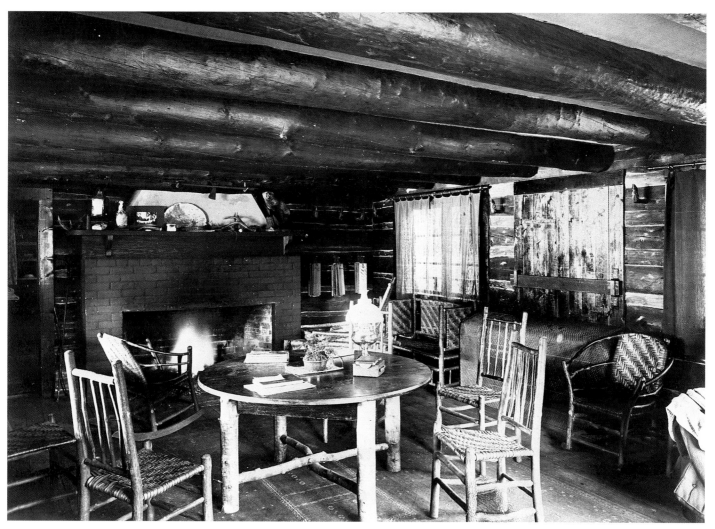

Historic summer cottage, circa 1920. Superior View

The summer cottage has served as a refuge from the noise and heat of urban life for well over 150 years. As the population in Michigan and its neighboring states shifted from rural settings to large cities, many people with the means to do so invested in a plot of land along a body of water and built a summer retreat. Traveling by rail or steamship to spend several weeks or months at the cottage became a family tradition for many urbanites. While reaching the cottage is now simply a matter of loading up the family vehicle and hitting the road, the long-standing tradition of summer vacation at the cottage remains.

Michigan's cottages first popped up along its Lake Michigan shoreline around towns like Petoskey, Pentwater, Grand Haven,

and South Haven. For the wealthier set, places like Mackinac Island and Les Cheneaux Islands in Lake Huron provided an isolated setting to which society's elite could escape. As Michigan's highway system began to take shape in the 1950s, many families opted for a cottage on one of the state's myriad quiet, inland lakes or rivers.

Today, cottages line the shore of the Great Lakes and many of the state's larger inland lakes. The summer population of towns like Houghton Lake, Cadillac, Petoskey, Charlevoix, Pentwater, and Ludington swell to many times their winter numbers with the influx of cottage-goers. Opening the cottage each spring has become an annual rite for many families, although with the increased popularity of snowmobiling and other winter sports, many families keep their cottage open year-round.

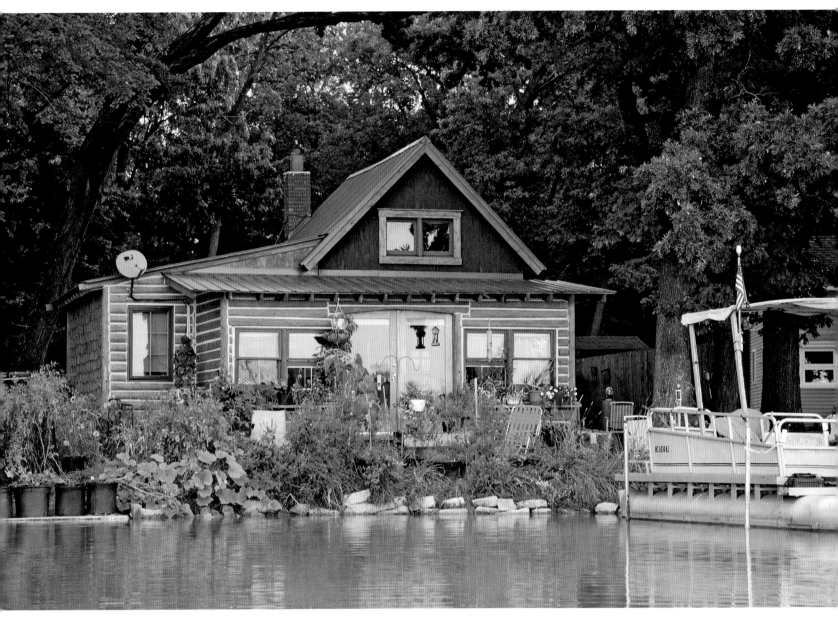

A waterfront cottage along an inland lake

Homemade signs

The Pavilion in Saugatuck, 1940. Superior View

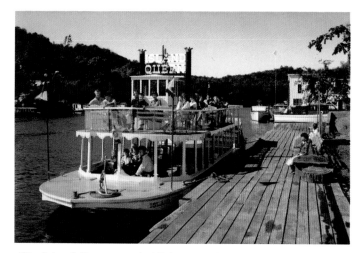

The Island Queen *on the Kalamazoo River.* Voyageur
Press archives

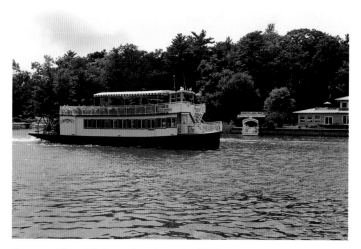

Saugatuck's paddleboats date from the 1860s.

SAUGATUCK/DOUGLAS

Most of the towns along lower Lake Michigan share two common events that shaped their collective history: the logging boom and the Great Michigan Fire of 1871. As the timber fell in Michigan's interior, sawmills and, eventually, towns sprang up along Lake Michigan at the mouth of every major river. The towns of Saugatuck and Douglas prospered as timber flowed down the Kalamazoo River to the waiting mills, but the story of these two towns diverged from that of others along Lake Michigan's coast on October 8, 1871, the day that the Great Michigan Fire began.

Saugatuck and Douglas lie only a few short miles from the fire, but they somehow were spared. As flames swept across Michigan that fateful autumn, they not only destroyed the homes and lives of people from Holland to Manistee to Port Huron, they also destroyed much of the state's architectural history. Saugatuck and Douglas are two of the few remaining places in Lower Michigan where buildings of the antebellum and post–Civil War Greek Revival and Italianate architectural traditions still exist. In the years following the fire, the two towns also processed much of the lumber used to rebuild Michigan and Chicago (as Chicago's Great Fire occurred the same day as Michigan's).

The artistic crowd has always had a penchant for Saugatuck and Douglas. In 1910, a group of Chicago artists launched a summer school for artists on the Ox-Bow Lagoon outside of Saugatuck. The institution has evolved into the Ox-Bow School of the Arts under an affiliation with the Art Institute of Chicago. The school sits on 115 acres of forest and dune and offers one- or two-week residency programs for students of the arts.

In the early twentieth century, Saugatuck was home to a huge entertainment center called the Pavilion that included a dance hall and later a movie house. Live acts from Chicago kept the music vibrant and contemporary and made Saugatuck/Douglas the place to be during the summer season. Nightlife in the two towns has also changed over the years. Nowadays, summer evenings draw shoppers to upscale galleries, restaurants, and boutiques or entice them to sit on a bench along the town's waterfront and watch the yachtsmen cruise into port from a day plying Lake Michigan.

Downtown Saugatuck

PEWABIC POTTERY

The one-hundred-year-old, Tudor-style building sits back from Detroit's East Jefferson Avenue, framed by unruly shrubbery and surrounded by a high fence. But like a brilliant mind concealed behind an unkempt persona, the genius of Mary Chase Perry Stratton lives inside the galleries and workspace within the walls of Pewabic Pottery.

Mary Stratton and her partner, Horace Caulkins, founded Pewabic Pottery in Detroit in 1903, working in a converted stable until 1907 when the studio on East Jefferson was built. Influenced by the American Arts and Crafts Movement of the late nineteenth and early twentieth centuries, Stratton sought to incorporate pure, simple form and excellent craftsmanship into her ceramics, rejecting the overwrought art that proliferated during the Victorian period. The high quality and beauty of Pewabic Pottery's vessels found a willing market with collectors. The pottery's ornamental tiles also found their way into many local and national landmarks, including Detroit churches and public buildings, the National Shrine of the Immaculate Conception in Washington, D.C., the Shedd Aquarium in Chicago, and Herald Square in New York City.

In 1966, five years after Mary Stratton's death, direction of the pottery was transferred to Michigan State University, and in 1981, ownership was assigned to the nonprofit Pewabic Society. The pottery's tiles are still in high demand for architectural use. Detroit Metropolitan Airport used 45,000 tiles in the new McNamara Terminal, and the new home of the Detroit Tigers, Comerica Park, is decorated with murals made from Pewabic tile.

Along with producing world-class commercial and artistic ceramics, Pewabic Pottery offers workshops, lectures, classes, internships, and residency programs for aspiring potters. The work of nationally recognized and emerging ceramic artists is displayed in the pottery's gallery, just upstairs from the busy workshop and kilns that have been producing fine ceramics for more than one hundred years.

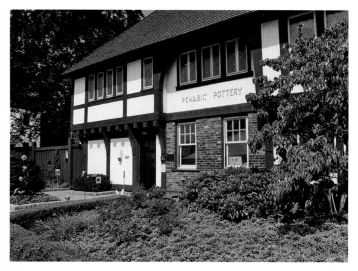

The home to Pewabic Pottery since 1907

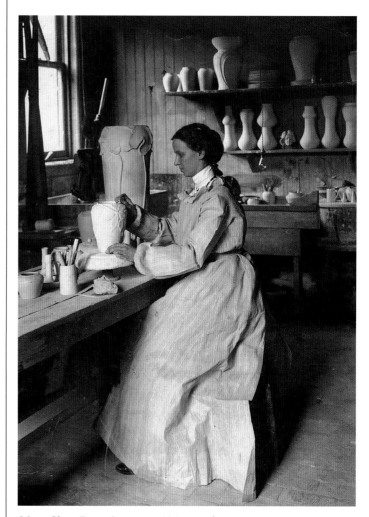

Mary Chase Perry Stratton, 1905. Pewabic Pottery

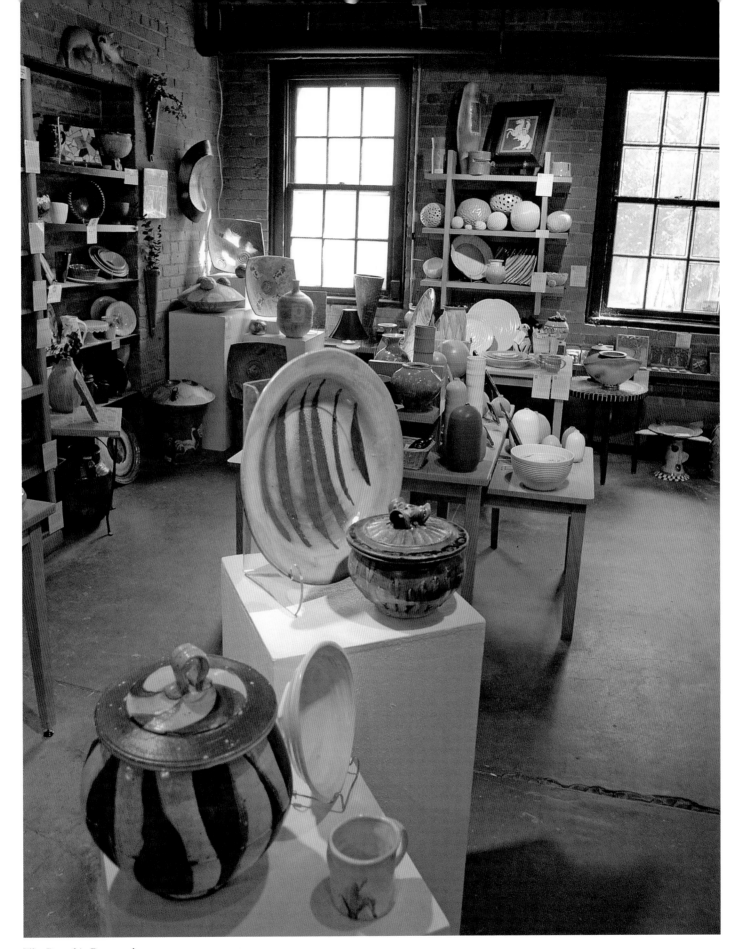

The Pewabic Pottery showroom

HISTORIC MARSHALL

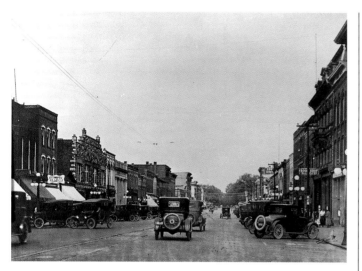

Marshall, 1910. Superior View

M arshall's founders aspired to make their city the capital of Michigan; Marshall's location made the city an important switching station for the fledgling Michigan Central Railroad; and Marshall's socially active citizens made their town a crucial stopover on the Underground Railroad. Throughout Michigan's history, Marshall has played a key role in the social and economic history of Michigan. Today, more than 850 homes and businesses in Marshall are included as part of the largest "small urban" National Historic Landmark District in the country. The community of Marshall has long been dedicated to preserving the past as it has moved into the future.

The architecture left behind by Marshall's past leaders and noted citizens is as varied and eclectic as any you will find in

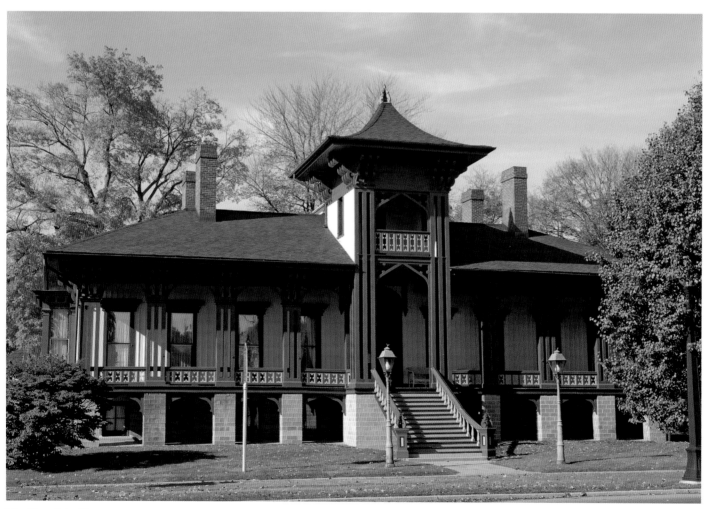

The Honolulu House

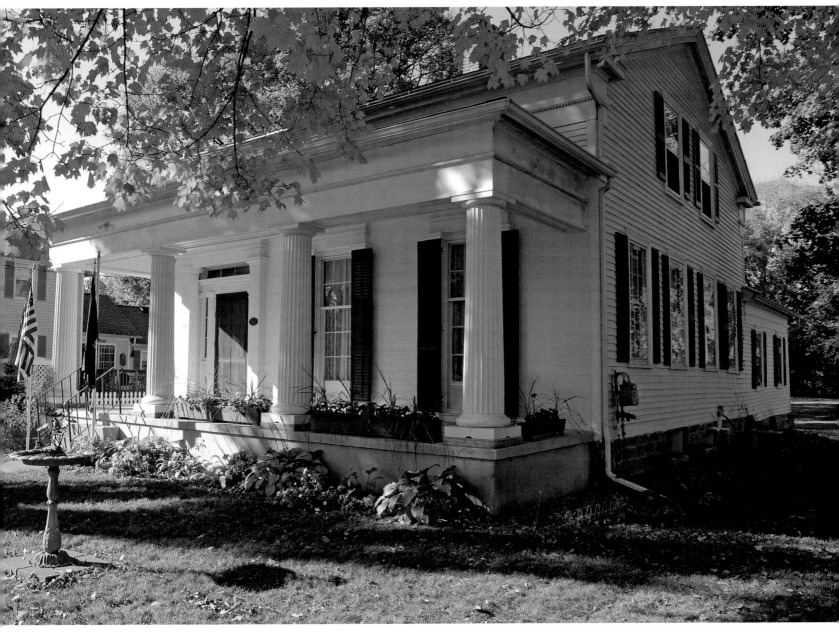

The anticipatory governor's residence in Marshall

Michigan. In anticipation of their city becoming Michigan's state capital, the people of Marshall constructed a governor's residence in 1839. The small but stately residence was built in the Greek Revival style, an immensely popular architectural style that swept across the United States and Europe in the late eighteenth and early nineteenth centuries. Marshall lost its capital aspirations to Lansing in 1847, but the completely restored residence still stands proudly on Marshall Avenue.

Perhaps the most unusual building to survive from Marshall's past is the Honolulu House, the former residence of the U.S. Consul to the Sandwich Islands (Hawaiian Islands), Judge Abner Pratt. The Honolulu House is an eccentric mixture of overhanging eves and the strong rectangular form of the Italianate architectural style combined with elements of Gothic Revival and flavored with vertical pillars and a pagoda-style roof that are unmistakably Polynesian. Harold C. Brooks purchased the house in 1951, saving it from the wrecking ball. Eleven years later, the Marshall Historical Society purchased the property and restored it to its former splendor.

A variety of businesses thrive in the nineteenth-century buildings that line Marshall's main thoroughfare, Michigan Avenue. In downtown Marshall it is possible to have a burger and a beer in a building that once boarded travelers crossing Michigan on stagecoach. Rounding out downtown are museums dedicated to American magic, the U.S. Postal Service, and the Civil War.

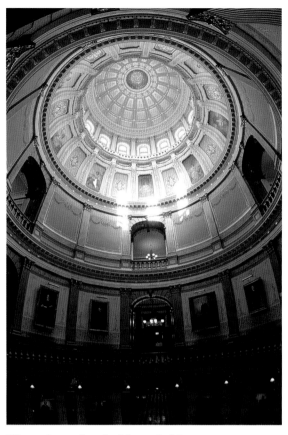

The oculus, or "eye," of the capitol dome

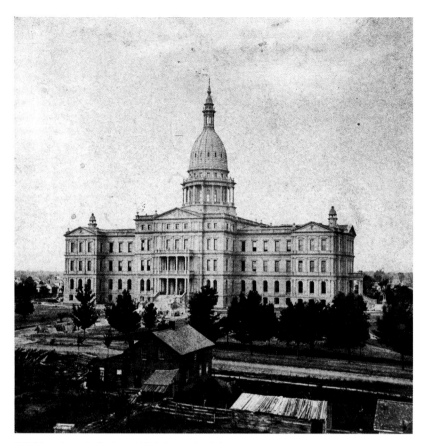

Michigan's capitol, circa 1875. Superior View

MICHIGAN'S CAPITAL

In 1847, Michigan celebrated its tenth year of statehood, but where the first capitol building would be built was still anybody's guess. Most residents favored Detroit, the state's largest city and the capital of the former Michigan Territory, but the final decision lay with the fledgling Michigan legislature. On the floor of the temporary legislative chambers in a territorial courthouse in Detroit, debate raged furiously as representatives from all around the state lobbied for cities in their district. In the end, to the surprise of many and the delight of few, the legislators chose a township in the midst of Michigan's untamed wilderness. In the winter of 1847–1848, the state's first capitol building was constructed in Lansing Township in south-central Michigan.

The hastily constructed wooden building served as Michigan's seat of government through the Civil War

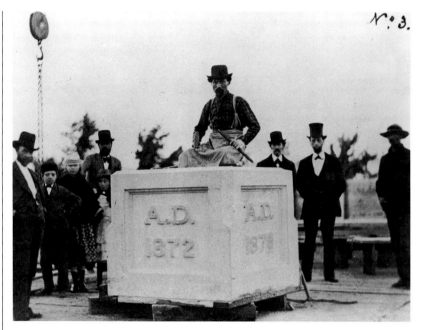

The first cornerstone for the capitol, laid in 1872. Archives of Michigan

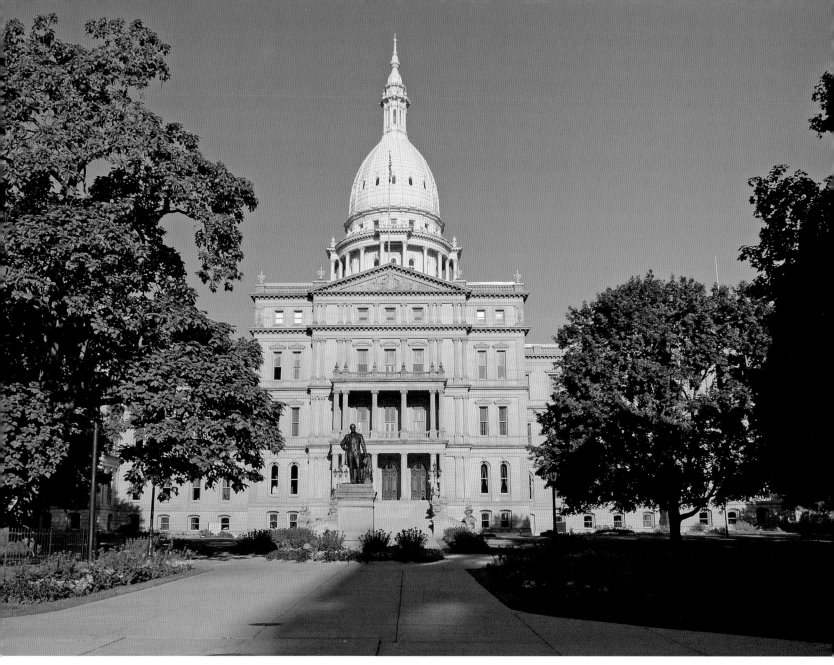

The capitol today

years and into the 1870s, when Governor Henry Baldwin decided a more dignified and fireproof capitol building was in order. The state legislature set aside $1.2 million for the new capitol building's construction and announced a nationwide contest to select a suitable architect. Elijah Myers, a then-unknown architect from Springfield, Illinois, captured the imagination of the building commissioners with a Neoclassical design topped with a distinguished cast-iron dome. After designing and overseeing the construction of Michigan's capitol, Myers went on to design more state capitol buildings than any other American architect.

Although the woodwork and ornate décor of Michigan's capitol building appear to the casual eye to be made of the highest-quality wood, stone, and metal, budgetary constraints led to the use of inexpensive substitutes that were hand-painted to mimic more expensive materials. The dark wooden doors and trim throughout the building are actually painted pine, not walnut, and the "marble" columns in the building's entranceway are really hand-painted iron.

Normal wear and tear eventually took its toll on the capitol building. In 1989, a three-year-long restoration project began that ultimately restored the original luster and craftsmanship to the aging building. Today, visitors marvel at the rotunda's glass tile floor and the star-studded oculus 160 feet overhead. The walls and ceilings of the hallways and legislative chambers are resplendent with beautifully rendered paintings and hand-carved woodwork. Tours of Michigan's capitol building are available for free during weekdays.

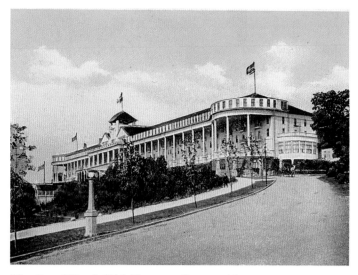

The Grand Hotel, 1913. Voyageur Press archives

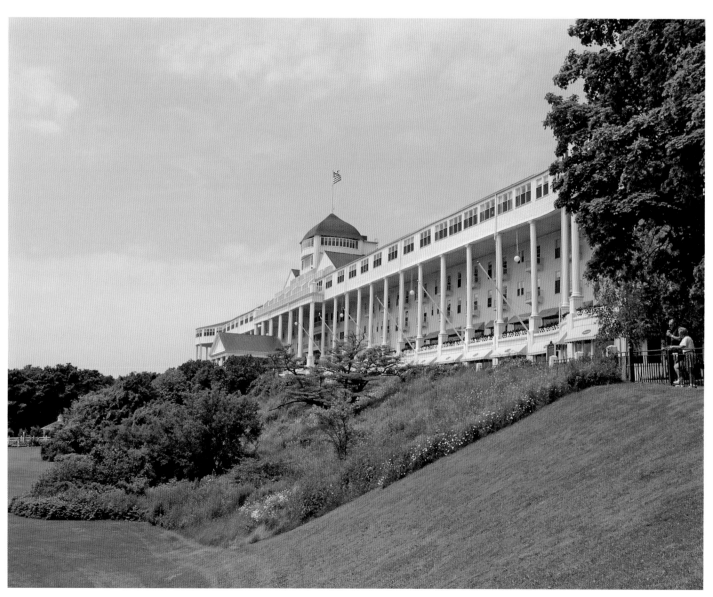

The Grand Hotel today

THE GRAND HOTEL

Conceived, designed, and built to be the premier resort on Michigan's premier vacation destination, the Grand Hotel on Mackinac Island has been welcoming guests since 1887. The hotel was the product of a consortium of railroad and shipping companies that banded together to finance and build the hotel to accommodate the growing number of vacationers arriving on Mackinac Island each year. The new hotel became so popular that just ten years after it opened, a new wing was added to the building.

The Grand Hotel's 880-foot-long front porch has long been its trademark and a favorite island meeting place. The hotel's guest list reads like a who's who of American politics. From Harry S. Truman to John F. Kennedy to Michigan's own Gerald R. Ford, presidents, vice presidents, first ladies, governors, and presidential candidates have visited the Grand Hotel over the years. Hollywood has also left its mark on the Grand. In 1946, Jimmy Durante and Esther Williams made the movie *This Time for Keeps* on location at the Grand Hotel and on Mackinac Island. In 1980, the movie *Somewhere in Time*, starring Christopher Reeve and Jane Seymour, was filmed at the hotel.

Today, the Grand Hotel is the setting for state and national conventions, business meetings, and luxurious family vacations. To augment its new eighteen-hole golf course, the hotel added the Millennium Wing in 2000, an addition that features forty-two new guest rooms and a large private meeting room.

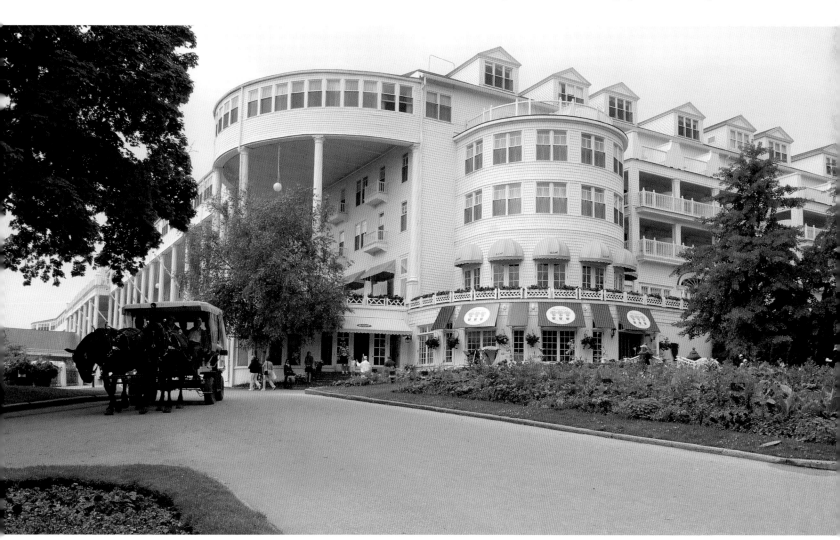

The Grand Hotel today

MACKINAC ISLAND

ichigan's premier vacation island has been a meeting place for as long as humans have plied the waters of the Great Lakes. The people of the Late Woodland Culture frequented the island, as did the earliest French explorers, missionaries, and fur traders. In the eighteenth century, Mackinac Island represented the key to military control of the upper Great Lakes and the island's Fort Mackinac was held at times by British and American forces. Due to its location near the intersection of Lakes Michigan, Huron, and Superior, Mackinac Island was the center of the eighteenth-century fur trade and the headquarters of John Jacob Aster's American Fur Company.

It was not until the mid-nineteenth century that visitors began coming to Mackinac Island strictly for pleasure. The rise of steamship and rail travel around the Great Lakes brought wealthy vacationers from Chicago, Detroit, and Milwaukee. These lumber barons, industrialists, and civic leaders built many of the beautiful Victorian-style "cottages" that grace the island today. Michigan's most famous inn, the Grand Hotel of Mackinac Island, as well as the Michigan governor's summer residence, were both built during the island's luxury housing boom in the late nineteenth and early twentieth centuries.

In 1960, Mackinac Island was listed as a National Historic Landmark and, despite its enormous popularity, still maintains its Victorian-era charm. Transportation on the island is limited to bicycle, horseback, or carriage; and the houses, shops, and historical landmarks are impeccably maintained. Visitors arrive daily during the summer season via personal watercraft or ferry service from Mackinaw City or St. Ignace, seeking respite from the summer heat or just to sample a piece of the island's famous fudge.

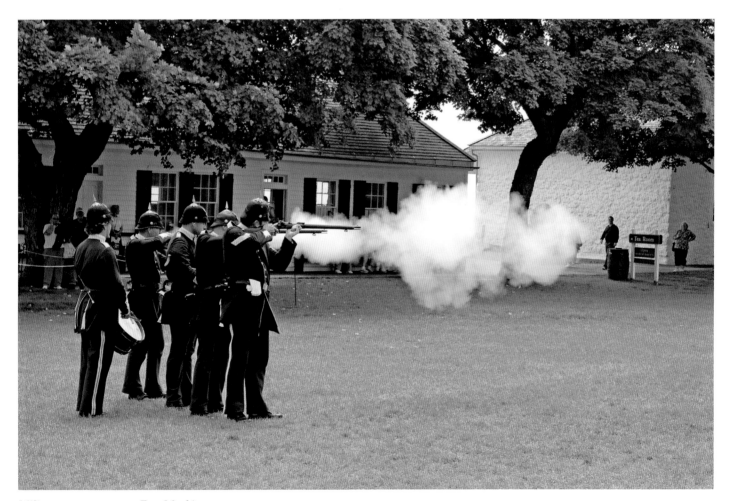

Military reenactments at Fort Mackinac

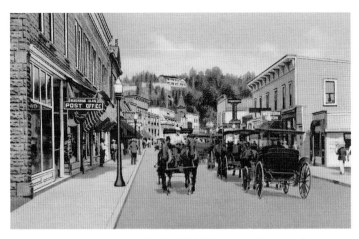

Main Street on Mackinac Island, 1938. Voyageur Press archives

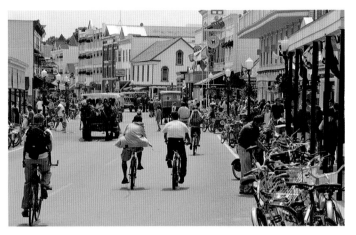

Main Street on Mackinac Island today

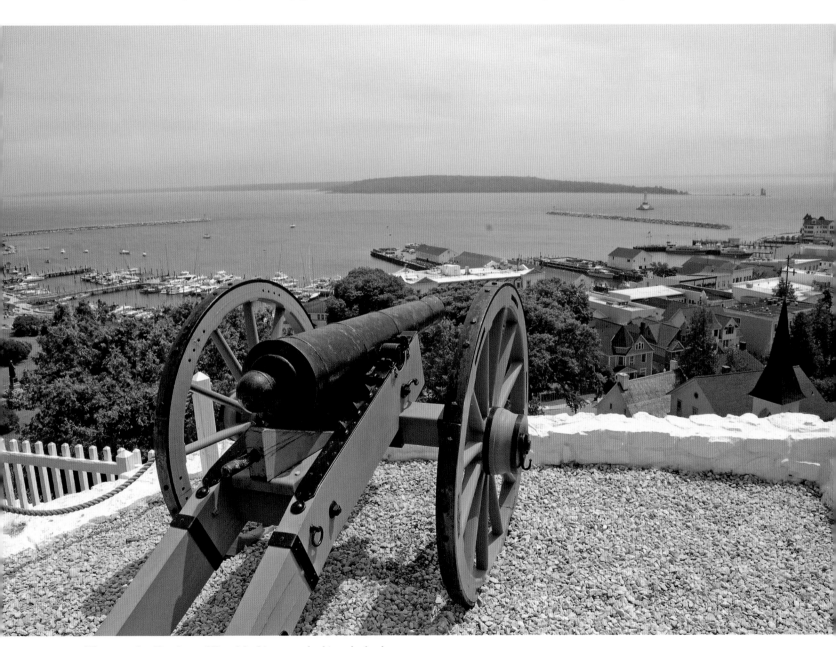

The stone fortifications of Fort Mackinac overlooking the harbor

THE CALL OF THE WILD MUSEUM

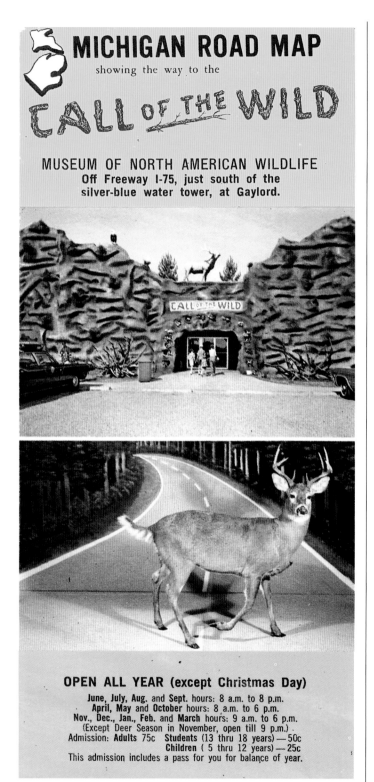

Call of the Wild Museum brochure, 1965. Call of the Wild Museum

From its current home next to Interstate 75 in Gaylord, the Call of the Wild Museum can trace its roots to the small town of Frederick along Old U.S. Highway 27, the old north-south route through the middle of the Lower Peninsula. The original museum near Frederick, called the Underground Forest, materialized from the imagination and industry of Carl and Hattie Johnson, a couple who had a passionate love of nature and deep roots in the North Country.

The original museum was a series of concrete underground rooms, built one at a time by Carl. As adjacent rooms were built, a door was cut between them until all the rooms were interconnected. Each room had a theme, much as the displays in the new museum have, that depicted expertly prepared animals posed within a hand-painted mural. The painted murals are themselves works of art that evoke the subtleties of the north woods in all its seasons. Local artists created the museum's murals and painted the building's unique façade as well.

The museum is run by two of Carl and Hattie's children, Janice Vollmer and Bill Johnson, who have taken special care to keep the museum true to its original mission. The museum's displays remain as vivid and fresh as the day they were constructed, and many new and innovative displays have been added. New works include an Arctic scene featuring an eleven-foot-tall polar bear along with an ingenious mirrored display depicting the headwaters of the nearby AuSable River in all four of Michigan's seasons.

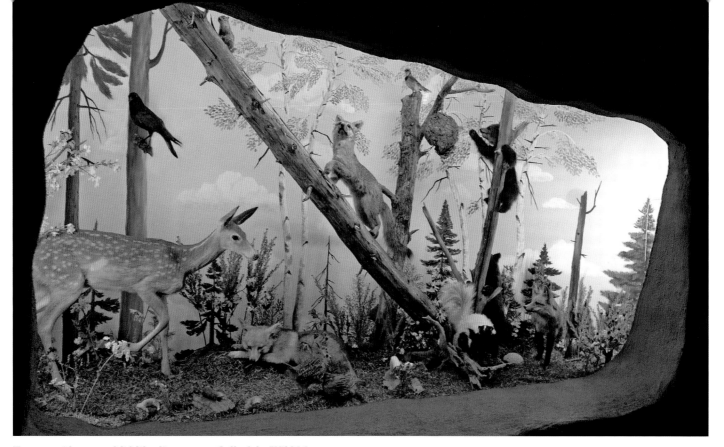

Expert taxidermy and lifelike dioramas at Call of the Wild Museum

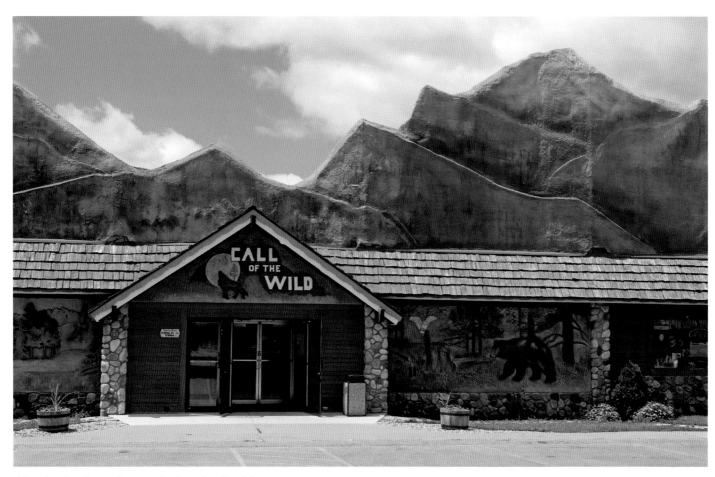

A hand-painted mural covers the front façade of the museum.

A doll made of seashells, 1965. Sea Shell City

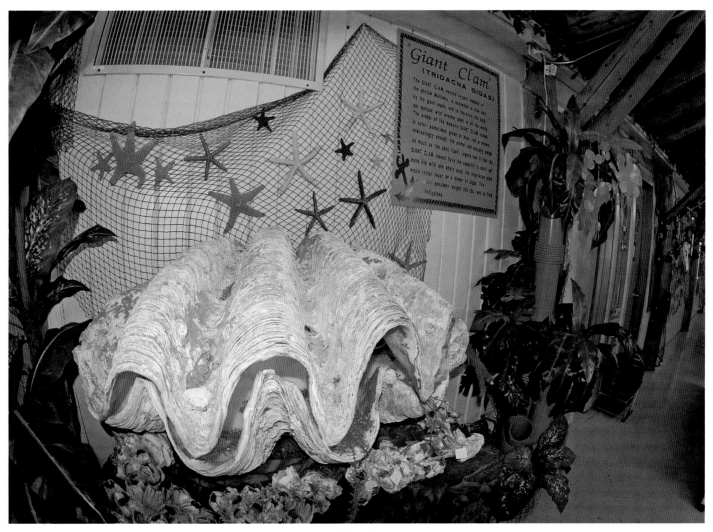

The famous man-killing clam featured on Sea Shell City's roadside billboards

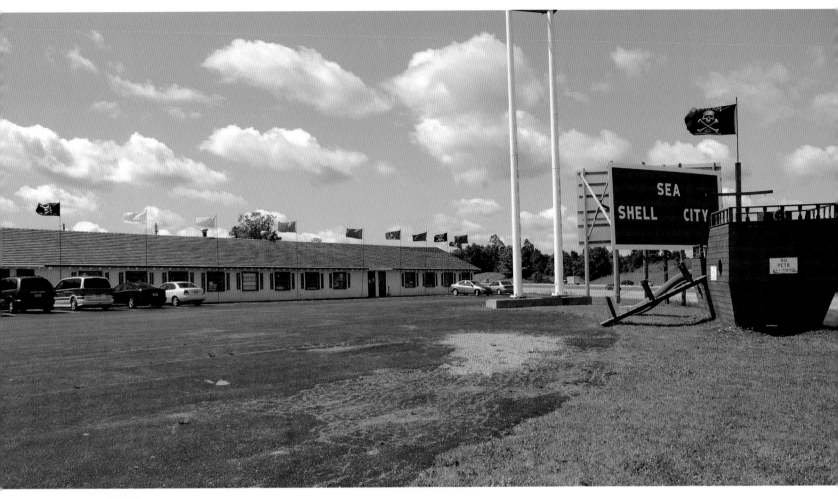

Sea Shell City

SEA SHELL CITY

ive hundred miles from the nearest ocean, sitting atop a hill a few hundred yards from Interstate 75 near the tip of Michigan's mitten, is one of the state's most unusual attractions: Sea Shell City. Housed in a low, white cinderblock building with a red façade roof, Sea Shell City looks more like a roadside motel than a retail store. But since 1957, cars full of curious travelers have stopped by to view and purchase treasures from Davy Jones' Locker.

Sea Shell City was the brainchild of Cecil and Adie Crant, who also opened and operated similar shops in Florida and Wisconsin's Dells region. In the end, the Michigan store was the most successful, due in part to the huge increase in north-bound vacation traffic along Interstate 75 when the Mackinac Bridge opened in 1957. To further tempt travelers, the Crants invested in a series of enticing billboards along Michigan's highways. The billboards promised a glimpse of the rare oddities of the sea, including a chance to see a giant, man-killing clam.

In the store's early years, a live alligator was kept in a pole barn behind the store. For a small fee, tourists could watch a local Indian wrestle the gator. During Michigan's cold months, the alligator was shipped south to winter in the warmer climes of Florida.

In 1990, Sea Shell City was quietly sold to Leslie Earl and Richard Hofer. The pair has succeeded in maintaining the store's character (and its tantalizing billboards) while improving the quality of the merchandise and displays. Sea Shell City continues to amaze new generations of travelers with gems from the Seven Seas right in the heart of Michigan.

The Edison Institute, circa 1930. Voyageur Press archives

THE HENRY FORD

The Henry Ford is a place where yesterday and today meld into a seamless portrayal of American industrial, cultural, and political history. The indoor-outdoor museum in Dearborn began its life as the Edison Institute, a structure filled with artifacts from the American Industrial Revolution and a school that emphasized hands-on higher education. Attending the Edison Institute's

Visitors can hitch a ride in a Model T.

dedication in 1929 were many of the world's scientific and industrial giants, including John D. Rockefeller, Marie Curie, and Orville Wright.

Named for Thomas Edison, a close personal friend of Ford's, the museum grew to include an outdoor village that contained the original buildings where Ford felt American history had been made. Edison's Menlo Park laboratory and all of its scientific equipment were moved to the site, along with the Wright brothers' bicycle shop and the homes of Noah Webster and Harvey Firestone. The outdoor museum eventually became known as Greenfield Village and the indoor area is now the Henry Ford Museum.

The Henry Ford Museum contains many rare objects from the nation's past. As American culture advances into a new century, the museum has added iconic items from the recent past to augment its collection of earlier American artifacts. The Kennedy Limousine from the fateful 1963 trip to Dallas and Rosa Parks' bus share floor space with Lincoln's chair from the Ford Theater and perhaps the oddest item in the museum, a test tube in which Henry Ford allegedly collected Thomas Edison's last breath.

An authentic Cotswold Cottage in Greenfield Village

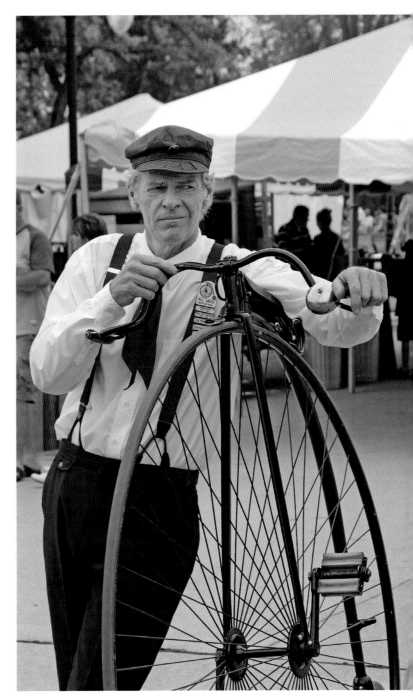

A period actor

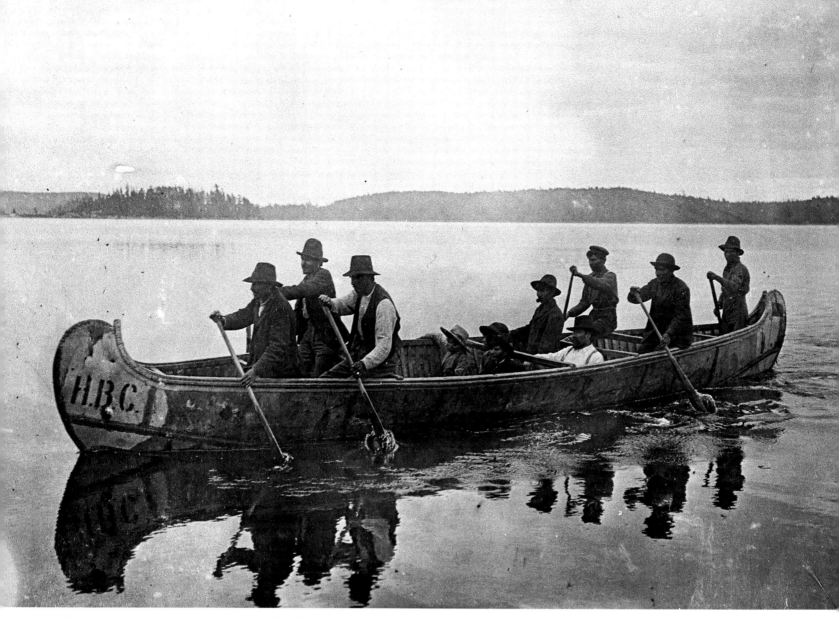

Hudson Bay Company freight canoe, circa 1900. Superior View

GREAT LAKES SHIPPING

Commerce on the Great Lakes began long before the Europeans arrived in the early seventeenth century. Paddling birch-bark or dugout canoes, Michigan's native people—especially the Odawa, whose name means "trader" in the Algonquin language—moved themselves and their trade goods around the peninsulas. During the fur trading boom of the eighteenth century, small birch-bark canoes were replaced by freight canoes measuring up to forty feet in length and having the capacity to carry several tons of cargo and crew.

In 1679, René Robert Cavelier, Sieur de La Salle, built the first European-style sailing vessel to navigate the Great Lakes, the *Griffon*. The sixty-ton vessel made its maiden voyage up Lake Huron to Michilimackinac and across upper Lake Michigan to Green Bay, where it loaded a fortune in furs for its return to Lake Erie. On her return voyage across Lake Michigan, the *Griffon* was lost with all hands.

The era of the Great Lakes clipper ship began during the nineteenth century as the timber and mining industries flourished and immigrants began to pour into Michigan. These

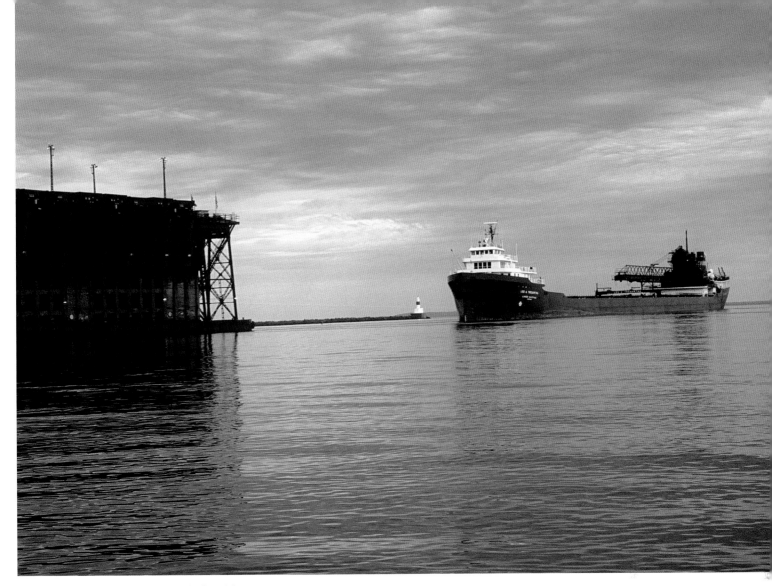

A freighter approaches the loading dock at Marquette.

beautiful wind-powered ships were manufactured in towns all along the shores of Lake Michigan. They were built from lumber harvested from Michigan's vast forests. During their heyday, an estimated 25,000 clippers plied the waters of the Great Lakes. Although a small number of sailing vessels continued to work the lakes through the late nineteenth century and early twentieth century, steamship travel had replaced the graceful clipper ships by the 1880s.

Steamships ruled the Great Lakes through the early twentieth century until the mammoth diesel-powered vessels seen on the lakes today arrived. Today's Great Lakes freighter may be one thousand feet long and is capable of carrying seventy thousand tons of cargo. The freighters not only play a crucial role in commerce but have become a tourist attraction of sorts around the lakes. In places like the Soo Locks, DeTour Passage, and the St. Clair River, tourists and locals alike spend many leisurely hours watching the immense crafts pass by.

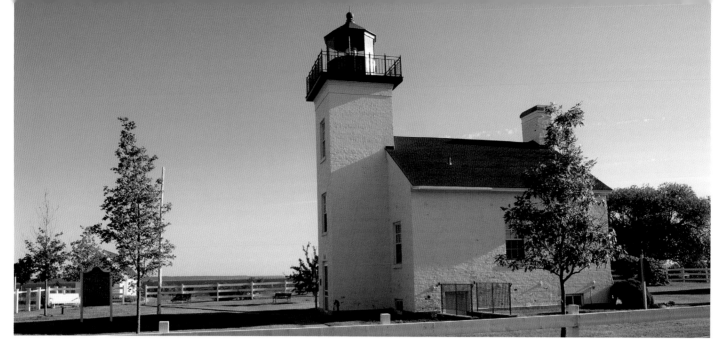

Sand Point Lighthouse and keeper's quarters in Escanaba

LIGHTHOUSES

The storms of the Great Lakes are legendary for their suddenness, size, and ferocity. With little warning and at any time of year, the normally placid blue chop of waves on the lakes can turn into a howling storm that occasionally rivals the intensity of a hurricane. In the two hundred years of commercial travel on the Great Lakes, storms, shoals, currents, and wind have claimed countless ships and sailors. To protect the maritime commerce of the Great Lakes, more than 120 lighthouses are scattered along Michigan's 3,100 miles of shoreline.

Michigan's oldest lighthouse sits at the former site of Fort Gratiot, near the point where Lake Huron empties into the St. Clair

The Fort Gratiot Lighthouse, circa 1890. Superior View

River. The Fort Gratiot Light was commissioned in 1823, and two years later, it was sending a feeble, whale-oil-fired beacon out over the perilous currents of Lake Huron's outfall. Barely three years after it was erected, a November gale toppled the poorly constructed structure. With shipping traffic on a steady increase through the St. Clair River, the government wasted no time in rebuilding a taller and sturdier light station on the site. The lighthouse was improved several times over the years and, despite nearly being destroyed by a ferocious storm in 1913, remains standing today.

In recent years, many of Michigan's decommissioned lighthouses have been purchased and restored by preservation groups. The Michigan Lighthouse Conservancy works with local groups to acquire and restore lighthouses that have been abandoned and fallen into disrepair. Knowledgeable and enthusiastic volunteers offer tours of many of the newly restored lighthouses.

Many of the lighthouses that once guarded the Great Lakes now offer enthusiasts a chance to stay for the weekend. The lighthouse at Big Bay Point on Lake Superior and Sand Hills Lighthouse on the Keweenaw Peninsula have been converted into luxury bed-and-breakfasts. On Lake Michigan's Leelanau Peninsula, the Grand Traverse Lighthouse offers weeklong stays as a lighthouse keeper's assistant. For a daylong family adventure, Whitefish Point Light on Lake Superior's Whitefish Bay is home to the Great Lakes Shipwreck Museum and is adjacent to a premier birding spot, the Whitefish Point Bird Observatory.

Big Sable Point Lighthouse in Ludington State Park

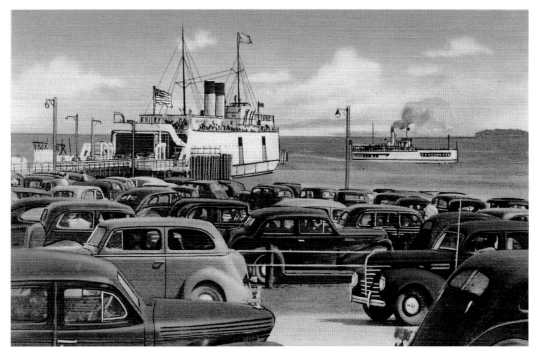

Ferry service from Mackinaw City to St. Ignace, 1938. Voyageur Press archives

FERRIES

As the days of automobile travel dawned on Michigan in the early twentieth century, so, too, did the era of the Great Lakes car ferry. Early ferry service moved railcars, freight, and passengers across the water, accommodating private automobiles as the need arose. When car transportation began to replace rail and steamship travel, many of the companies that specialized in transporting railcars switched to ferrying automobiles. From World War I through the Great Depression and into the 1950s, the ferry service thrived on the lakes.

The 1950s saw major expansions in the ferry service on Lake Michigan. The S.S. *Spartan* and the S.S. *Badger*, the two largest car ferries ever to sail the Great Lakes, were added to the fleet in 1952. Business across Lake Michigan was brisk until the 1970s, when the C&O Railroad, the parent company of the Ludington-based fleet, decided to quit the business.

In 1991, businessman Charles Conrad purchased the fleet and founded the Lake Michigan Car Ferry Service. The ferries now carry thousands of RVs, touring motorcycles, and family autos across the water each summer between Ludington, Michigan, and Manitowoc, Wisconsin.

In the years before the Upper and Lower Peninsula were joined by the Mackinac Bridge, the Michigan Department of State Highways provided ferry service across the Straits of Mackinac. Service across the straits began in 1923 with the *Ariel*, a riverboat that hauled twenty cars at a time across the five miles of water between Mackinaw City and St. Ignace. In the summer of 1924, two more ferries were added to the fleet. That year, 38,000 vehicles made the crossing between the peninsulas.

Winter service across the frozen straits began in 1931 aboard a railroad-owned icebreaker, a trip that was not for the faint of heart. During the November deer-hunting season, traffic would back up for miles in Mackinaw City as hunters queued up for the ferry ride to the Upper Peninsula. The yearly ritual took on a carnival atmosphere with hunters socializing outside their vehicles while vendors walked through the traffic jam selling pasties and refreshments. Car ferry service across the straits passed into history in November 1957 with the opening of the Mackinac Bridge.

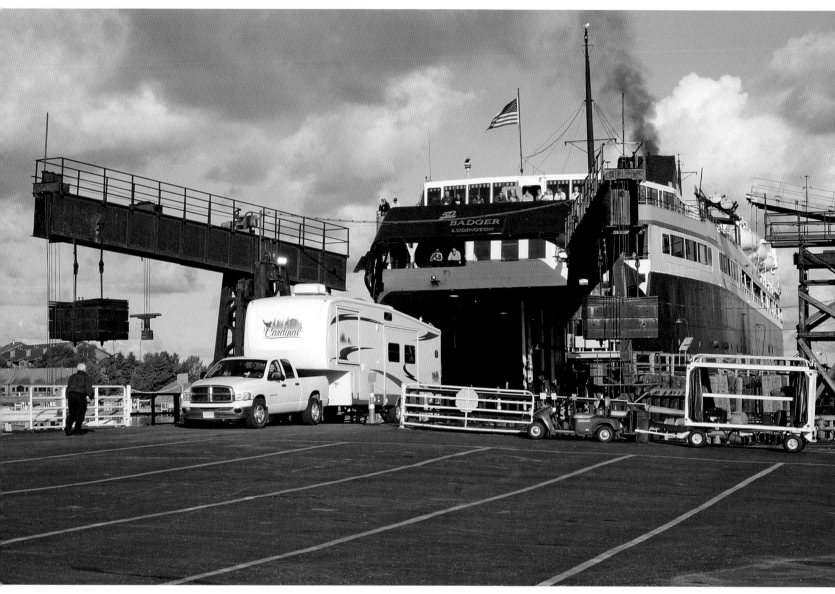

The S.S. Badger, *one of the last remaining car ferries on the Great Lakes*

THE MACKINAC BRIDGE

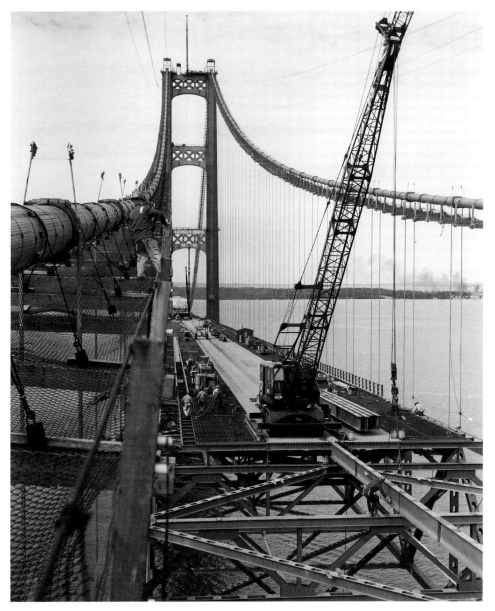

Construction of the Mackinac Bridge, 1956. Archives of Michigan

Spanning the Straits of Mackinac between the Upper and Lower Peninsulas, the Mackinac Bridge is one of Michigan's most recognizable icons. The bridge opened to automotive traffic on November 1, 1957, after nearly seventy-five years of legislative wrangling, false starts, a world war, and a couple of questionable proposals to move traffic across the straits. Once the construction finally began in May 1954, it took only three years to construct the five-mile-long suspension bridge.

The first recorded call for a permanent link between the Upper and Lower Peninsulas came in 1884 with a story in the *Grand Traverse Herald*. The *Herald*'s story pointed out the failures and inadequacies of the private ferry system that serviced travelers and commerce moving between the peninsulas and called instead for a bridge or tunnel to be constructed. Several years later, the directors of the new Grand Hotel on Mackinac Island lamented that business at their hotel was suffering for lack of a route across

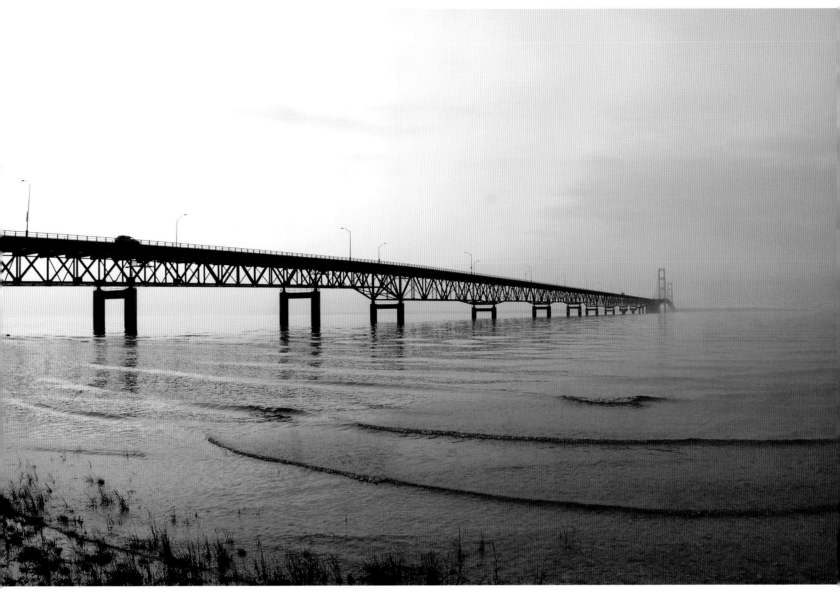

The Mackinac Bridge on a summer evening

the straits. Despite the growing clamor, talk of a bridge failed to inspire any legislative action.

The lack of action on a link between Michigan's peninsulas did not stop the flow of ideas on how it should be accomplished. The state highway commissioner envisioned a floating tunnel across the straits. The idea of a series of causeways and bridges linking Cheboygan, Bois Blanc Island, Round Island, Mackinac Island, and finally St. Ignace was tabled. In the end, the Michigan legislature opted to sponsor a ferry service across the straits.

With the opening of the Mackinac Bridge in 1957, a new era in travel began. The ferry service across the straits was discontinued and traffic bottlenecks during the summer vacation season and the November deer-hunting season all but disappeared. While many people missed the adventure and romance of the cross-straits ferry service, especially during the winter months aboard an icebreaker, the convenient new bridge became an instant Michigan icon.

On November 1, 2007, the Mackinac Bridge celebrated its fiftieth birthday. From its construction to its silver anniversary, the bridge has compiled some amazing statistics. The design and detail of the bridge required 85,000 blueprints and 4,000 engineering drawings. The bridge's construction employed the skills of over 11,000 people. The main cables holding up the suspension are 24.5 inches in diameter and weigh a total of 11,840 tons. Nearly 5 million steel rivets and over 1 million steel bolts hold the steel superstructure together. On September 25, 1984, the fifty-millionth vehicle crossed the bridge, and two years later, the last of the Mackinac Bridge bonds were retired. By 1998, one hundred million vehicles had passed over the bridge.

THE AuSABLE RIVER

Clean, cold, and brimming with trout, the AuSable River cuts a winding path through the sandy moraines of northern Lower Michigan. For Native Americans and later for French voyageurs, the AuSable served as a water route from Michigan's interior to Lake Huron. The logging boom of the nineteenth century saw millions of board feet of lumber float down the AuSable to sawmills on Lake Huron. Today, the AuSable is one of northern Michigan's premier trout streams and a favorite destination for canoeists seeking a leisurely day of paddling.

The town of Grayling sits near the headwaters of the main branch of the AuSable. The town got its name from the grayling, a troutlike member of the arctic char family that has an enormous dorsal fin. Grayling was the center of logging operations in central Lower Michigan during the late nineteenth century and the starting point for huge log drives down the AuSable. The effects of the log drives on the river's ecology drove the indigenous grayling to extinction and decimated native trout populations.

When the big timber in the river's watershed was gone and the log drives ceased, the AuSable became the focal point for a massive fish-stocking program designed to bring trout back to the river. The river was stocked with rainbow and brown trout that were raised in a hatchery in Grayling; soon the AuSable was drawing anglers from all over the Midwest. Many stretches of the mainstream AuSable are set aside for fly fishing only, with a strict catch-and-release policy. The mainstream of the AuSable River east of Grayling from Burton's Landing to the Wakely Bridge is known affectionately to fly fishers as the "Holy Waters." This section of river is famous for its beauty and its population of trophy brown trout.

A stretch of the south branch of the AuSable River called the Mason Tract holds a special place in the hearts of fly fishers. The original parcel of 1,500 acres adjoining the river was donated to the people of Michigan by George Mason, the president of the Nash Car Company. Purchases of nearby land have nearly doubled the size of the original tract. The pristine segment of the AuSable that runs through the Mason Tract is the exclusive domain of catch-and-release fly fishers.

Canoe camp along the AuSable River

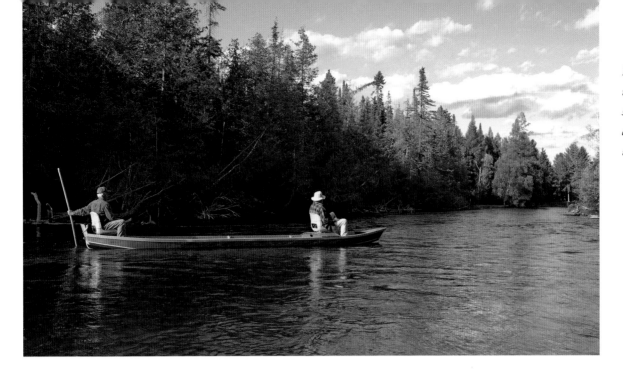

Modern AuSable
riverboats are
sleek, stable,
and beautiful
watercraft.

An original AuSable riverboat, 1952. Superior View

TROUT FISHING

Conservation officer Rube Babbitt fishing the AuSable River, 1930.
Crawford County Historical Society

I t is known as the quiet sport where the act of playing is itself the prize. Trout fishing demands knowledge, skill, and patience, whether it is practiced under the drizzling skies of a fading November afternoon or on a pastoral June evening. As Ernest Hemingway's Nick Adams discovered on Michigan's Big Two-Hearted River, trout fishing connects you to nature—and to yourself.

Northern Michigan's hundreds of miles of coldwater trout streams have provided countless hours of pleasure for anglers. The names of Michigan's rivers that run clear and cold have become synonymous with trout fishing: the AuSable, the Manistee, the Jordan, and the Pere Marquette. Waiting in the river's riffles and pools, facing upstream and holding against the current, are rainbow, brown, and native brook trout.

Michigan's rivers suffered greatly during the logging era. The huge logs that skidded and bumped downstream to the mills ripped apart the delicate streambeds and churned up tons of sand and debris in the water, destroying breeding beds and clogging the gills of fish with silt. In the AuSable River, the sheer volume of logs in the river raised the water temperature enough to wipe out the grayling, a member of the arctic char family that depended on cold water to survive.

At the end of the nineteenth century, local conservation clubs began raising trout in hatcheries to release into Michigan's now-healing rivers. One of Michigan's oldest hatcheries, the Harrietta State Fish Hatchery west of Cadillac, opened in 1901

to restock rivers with brown and rainbow trout, a mission that continues today. A similar hatchery project in Grayling on the AuSable River failed to re-establish the grayling but was successful in stocking the river with a vigorous population of brown trout. Stocking programs in Michigan have been very successful, and today about 40 percent of the fish taken on Michigan's rivers have been hatchery-raised.

The returning health of Michigan's coldwater rivers and the success of fish stocking programs marked the beginning of the recreational trout fishing boom. Stretches of prime river have been set aside as catch-and-release, fly-fishing-only areas that attract anglers from around the globe. Despite the popularity of trout fishing on many of the state's rivers, it is still possible to enjoy a day of solitude on a Michigan trout stream.

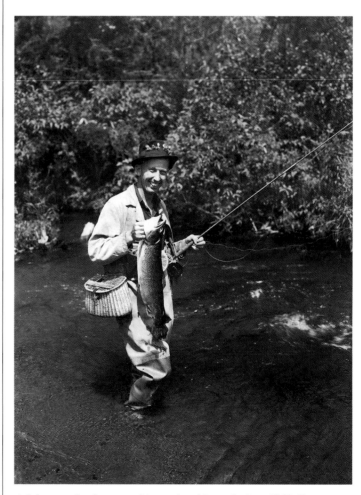

A fisherman lands a trout bigger than his creel, circa 1960. Otsego County Historical Society

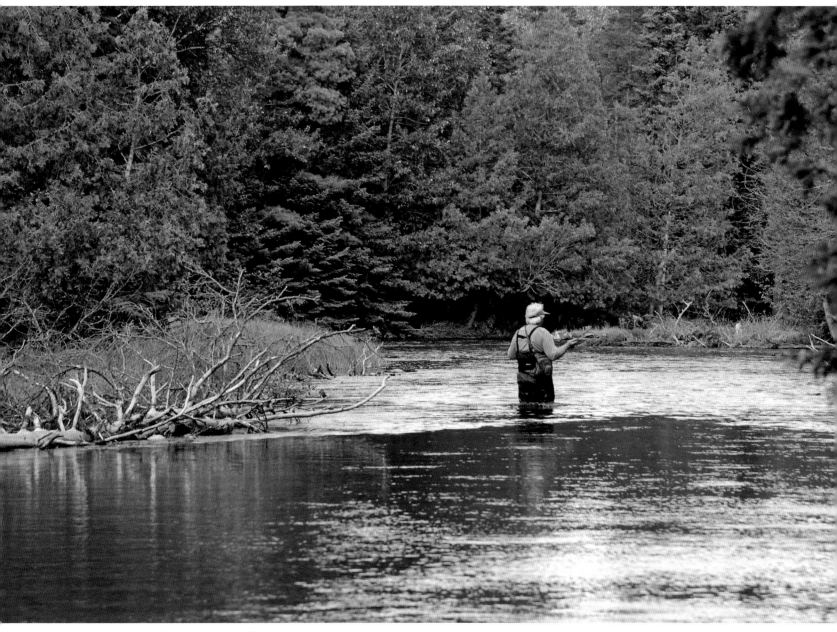

A modern-day fisherman on a Michigan trout stream

Detroit is home to the Red Wings Hockey Club.

SPORTS

From the 120-year-old Annual Invitational Ski Jump at Suicide Hill near Ishpeming, to Friday night high-school football under the lights in Onaway, to fanatical fans cheering the Red Wings through a game at Detroit's Joe Louis Arena, Michigan is a sports-loving state.

Michigan has produced many world-renowned athletes over the years, and many of professional sports' best have spent their careers playing here. Basketball's Irwin "Magic" Johnson was born in Lansing, and tennis star Serena Williams and baseball's Hal Newhouser were also born in Michigan. Ty Cobb and Al Kaline, two of professional baseball's greatest players, spent their careers with the Detroit Tigers, and Gordy Howe, a name synonymous with professional hockey, spent his career with the Detroit Red Wings.

Collegiate sports have a long and illustrious history in Michigan. Only ten years after the first intercollegiate football game was played in 1869, the University of Michigan fielded a football team, starting a program that would become one of college football's finest. Today, the state's largest public universities, Michigan and Michigan State, have stellar sports programs and an intrastate rivalry as hotly contested as any in the nation.

Professional sports have been a part of Detroit and Michigan history for well over a century. In 1901, the Detroit Tigers Baseball Club took the field at Bennett Park for the first time, only to have their first outing postponed by rain. When the National Hockey League expanded from Canada into the United States in the 1920s, the Detroit Red Wings began a run that would bring eleven Stanley Cup championships to Detroit and earn the city the nickname "Hockeytown." In 1920, Detroit's first professional football team, the Detroit Heralds, came to town and after several iterations became, in 1934, the Detroit Lions. The Detroit Pistons of the NBA and the Shock of the WNBA bring exciting professional basketball to the Motor City.

Safe at home! Al Kaline slides past Yankee catcher Yogi Berra at Tiger Stadium, circa 1955. Superior View

Comerica Park, home of the Detroit Tigers

POP

The saying goes "You might be from Michigan if you order a ginger ale and expect to get Vernors." Before pharmacist James Vernor left for military service in the Civil War, he stored a new drink he was concocting in an oak barrel. When he returned from the war, he opened the sealed barrel and sampled the contents to find that the aged mixture of ginger, vanilla, water, and seventeen other ingredients had mellowed to a zesty, flavorful drink like none he had ever tasted. Vernors Ginger Ale was born.

James Vernor was energetic and hardworking, and he began selling his new drink at the soda fountain of his drugstore in downtown Detroit. The public loved the unique new soft drink, and demand soon outstripped Vernor's ability to sell the product solely from his store. To keep his customers happy, Vernor began franchising his soft drink to other soda fountains around the city. In 1896, Vernor closed his pharmacy and opened a bottling plant on Woodward Avenue near the Detroit River. For the next ninety years, Vernors Ginger Ale

Vernors soda fountain on Saginaw Street in Flint, 1941. Voyageur Press archives

was produced and bottled in Detroit exactly as James Vernor had intended.

Ten years after James Vernor opened his plant, Ben and Perry Feigenson opened the Feigenson Brothers Bottling Works and introduced Detroit to fruit punch, strawberry, and grape

The Vernors bottling plant on Woodward Avenue in Detroit, 1940. Superior View

Above and below: *A whimsical mural, created in 1932, on Saginaw Street in Flint*

soda. The two brothers coined the word "pop" to describe their carbonated beverage and the sound it made when the bottle was opened. The name "pop" soon became synonymous with soda, and Michiganders still refer to carbonated soda as pop.

In the 1920s, Feigenson Brothers Bottling Works shortened its name to Faygo, creating one of the most recognizable beverage names in Michigan. Faygo pop has introduced many new flavors over the years and, despite being purchased by the National Beverage Corporation, is still produced and bottled in Detroit.

THE NATIONAL CHERRY FESTIVAL

THE MORGAN CHERRY ORCHARD IN BLOSSOM, TRAVERSE CITY

A cherry orchard near Traverse City, circa 1941. Voyageur Press archives

Protected from the heat of summer by the cool Lake Michigan breeze and sheltered from the drying winter wind by a blanket of snow, the land around Grand Traverse Bay provides ideal conditions for growing fruit trees, especially cherries. Not long after the first Europeans arrived in the area, Peter Dougherty, a Presbyterian missionary, planted a small cherry orchard on the Mission Peninsula. To the surprise of local farmers, the cherry trees not only grew, but flourished. In 1893, forty years after Reverend Dougherty sowed his small orchard, the first commercial cherry orchard was planted nearby and the Grand Traverse cherry industry was founded.

As the cherry orchards grew in number and size around Grand Traverse Bay, so did the cherry processing industry. Processing plants sprang up near orchards, and soon canned cherries were making their way to markets all over the Midwest. The cherry harvest provided hundreds of people with jobs as they handpicked the ripe fruit and packed it off to nearby canneries. The tart cherry harvest has since been mechanized, but sweet cherries are still plucked from the trees by hand.

The National Cherry Festival held in Traverse City each July traces its roots back to 1926 and a ceremony called the "Blessing of the Blossoms." Held to celebrate the yearly cherry crop in the Grand Traverse region, the ceremony was moved in 1933 from spring blossom time to harvest time to encourage the public to enjoy the fruits of the cherry grower's labor. Over the years, the festival has grown to include a variety of family activities and now draws over half a million visitors during its eight-day run each July.

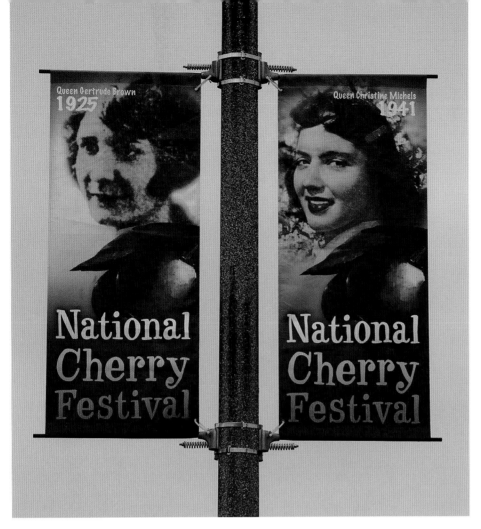

National Cherry Festival banners

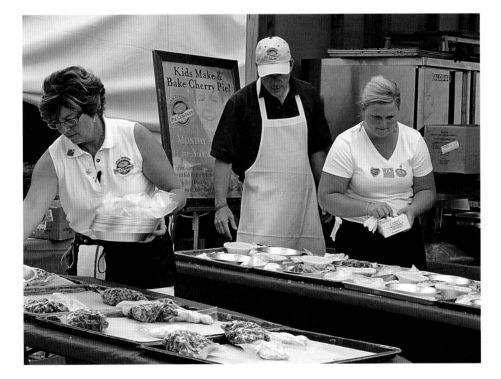

Cherry pies are a tradition at the National Cherry Festival.

THE BIG SPRING

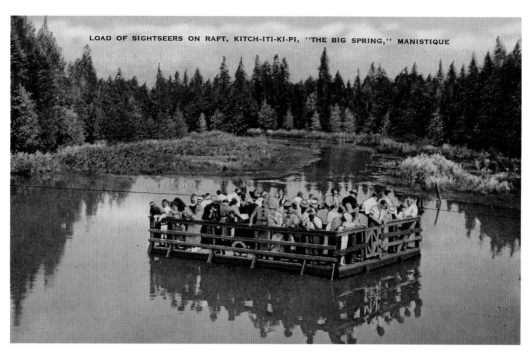

The original raft on the Big Spring, circa 1941. Voyageur Press archives

Palms Book State Park is small, especially by Upper Peninsula standards. Although the park encompasses less than four hundred acres, it contains one of Michigan's rarest natural treasures: the Big Spring.

In the early 1920s, a businessman named John Bellaire moved to Manistique on the north shore of Lake Michigan, not far from the Big Spring. During a visit to the spring with a friend, Bellaire saw through the fallen trees and logging debris that clogged the otherwise clear, emerald water of the spring and envisioned its true natural beauty. Bellaire watched in awe while the sand at the bottom of the spring swirled and danced as ten thousand gallons of water per minute gushed in from unseen fissures in the bedrock. From his first visit until his last days, Bellaire's life would be intertwined with this mysterious and beautiful spring.

In 1926, Bellaire arranged the sale of the land surrounding the spring through the Palms Book Land Company to the State of Michigan for the sum of ten dollars. With the help of the Michigan Department of Conservation and the Civilian Conservation Corps, the spring was cleaned up and the site readied for tourists; but Bellaire's work was not done.

John Bellaire became the Big Spring's biggest promoter, often closing his five-and-dime store in Manistique to escort visitors to the spring. Bellaire and a friend are also said to have concocted legends about the spring, including its "Indian" name, Kitch-iti-kipi, to raise curiosity and bring in more visitors. The stories of Indian maidens and lost love, along with tales of the magical healing powers of the spring, may have been farfetched, but tourists ate them up. Just as Bellaire had hoped, word spread about Kitch-iti-kipi, Michigan's mysterious spring.

Despite the lack of a campground, swimming beach, or fishing facilities, Palms Book State Park draws a crowd each summer. Visitors still marvel that every nuance of the roiling sand and lime-encrusted trees is visible through forty feet of acid-clear water. A hand-operated, open raft spirits visitors to the center of the spring, where you feel you could reach down and touch the fat trout that hang suspended just above the bottom of the pool. And visitors still lower their voices in reverence as they gaze into the depths of Kitch-iti-kipi and leave with a renewed appreciation of Michigan's beauty. John Bellaire would be proud.

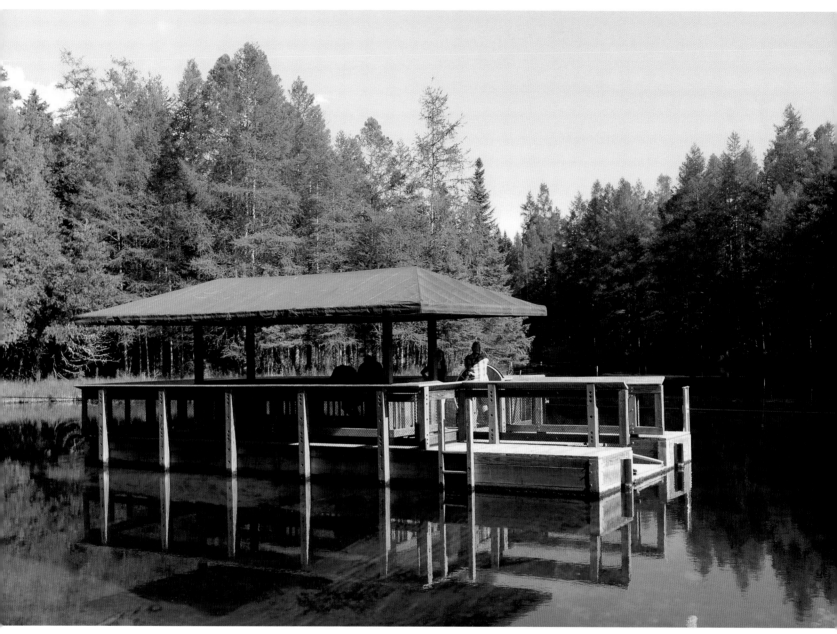

The Big Spring raft today

FORT MICHILIMACKINAC

efore it appeared as the tip of a mitten on any map, and before the earliest French missionaries pulled their paddles against the westerly headwind blowing off Lake Michigan, the straits of Mackinac were a well-known landmark. Each spring, the Ojibwa and Ottawa made temporary encampments nearby to make maple sugar and to reunite with their clan after a winter of isolation on family hunting grounds in Michigan's interior. When the pragmatic French traders arrived in the eighteenth century, it was only natural that they chose to establish a trading post on the south shore of the straits. During the French and Indian War, the trading post became Fort Michilimackinac, the seat of the French military presence on the western frontier of New France.

At the end of the French and Indian conflict, the victorious British took control of the fort and the sizeable fur trade that the French had established. The French traders who stayed behind accepted their new English masters, but the local Native Americans who had fought alongside the French did not. Emboldened by the success of Chief Pontiac, who was waging war against the British in southern Michigan, Ohio, and Ontario, the Ojibwa and Ottawa hatched a plan to drive the British out of Michilimackinac.

Under the guise of playing a game of lacrosse outside the fort, the warriors threw the ball over the picket fence and rushed through the open gate past the guards who had come outside to watch the contest. The garrison was taken completely by surprise, and in a matter of minutes, the Ojibwa and Ottawan warriors had control of the fort. The victory was complete but short-lived, as a contingent of British soldiers arrived from Detroit within weeks and reclaimed Michilimackinac.

The fort at Michilimackinac was moved by the British in 1781 to a more secure and strategic location on Mackinac Island, and what was not moved was burned. When modern-day Mackinaw City was platted in 1857, the site of the former fort was set aside as a community park.

In 1959, Michigan State University contracted with the State of Michigan to begin an archaeological excavation of the site. Over the past fifty years, archaeologists have uncovered a treasure trove of artifacts both inside the fort walls and around the perimeter of the site. The archaeological excavation of Fort

The excavation of Fort Michilimackinac, 1960. Archives of Michigan

Michilimackinac is the longest ongoing project of its kind in the United States.

Today, the grounds are part of the Colonial Michilimackinac State Park. The fort has been painstakingly reconstructed, from the cedar palisades, catwalks, and gun towers to the officers' quarters, traders' homes, and barracks. Costumed interpreters reenact life in colonial times while British redcoats hold military drills on the parade grounds and fire a cannon across the Straits of Mackinac.

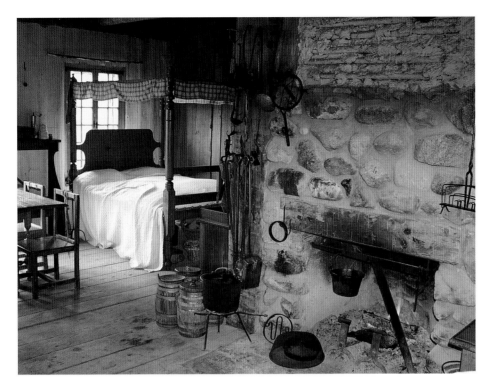

Fort Michilimackinac building furnished as it was in colonial times

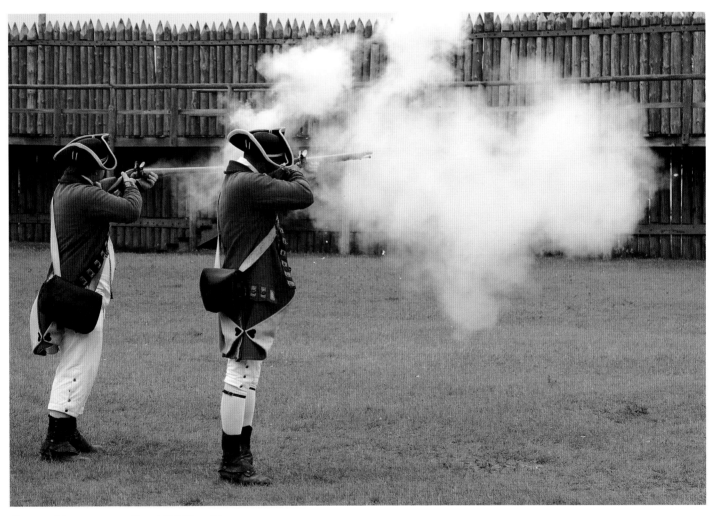

Costumed interpreters at Fort Michilimackinac

THE DETROIT ZOO

In 1911, Detroit was a city of wealth and promise. Henry Ford's factory was mass-producing the Model T, James E. Scripps sat at the helm of what would become a newspaper dynasty, and the Burroughs Company was producing office machinery that could add and subtract. In the midst of these heady times, the city's elite formed the Detroit Zoological Society with the aim of providing residents with a world-class zoological park.

For the first several years of its existence, the Society purchased and then sold land around the city until, in 1916, it acquired land from the Hendrie farm along Woodward Avenue north of the city. In 1924, the Detroit Zoological Park Commission was formed and construction began on Detroit's new zoo. The official opening dedication for the new Detroit Zoo took place on August 1, 1928, in front of a crowd of dignitaries—who nearly got to witness the acting mayor of Detroit being mauled by a polar bear.

Acting Mayor John C. Nagel had arrived late for the ceremony and, in his haste, parked behind the polar bear exhibit. Just as he dashed around the front of the exhibit to address the crowd, Morris, the zoo's new polar bear, hurdled his protective moat to retrieve some bread left by his keepers. The bear came face-to-face with Nagel. Apparently unaware that the polar bear is capable of killing a two-thousand-pound walrus with a single swipe of its massive paw, Nagel extended his hand and walked toward the bear, saying, "He's the reception committee." Morris' quick-thinking keepers rushed forward and drove the bear back before the interaction forced Detroiters to call a special election to replace their mayor.

Despite its shaky opening ceremony, the zoo opened to the public on August 5, 1928, drawing an estimated crowd of 150,000 people. Over the years, the Detroit Zoo has provided Detroiters with everything from elephant rides to tortoise rides. It features chimpanzee shows, miniature railroad rides, and animals from around the globe. In 1968, the zoo opened the penguinarium, the first air-conditioned penguin display in North America. Recent additions include the Arctic Ring of Life display, featuring an underwater tunnel where visitors can view seals and polar bears as they swim by.

The fountain near the zoo entrance, circa 1930. Voyageur Press archives

The butterfly house is home to exotic species.

The Arctic Circle of Life exhibit

PIGEON RIVER ELK HERD

The first reintroduced elk in Michigan, 1918. Archives of Michigan

The 1870s saw the last of northern Lower Michigan's great forests disappear under the whipsaw, and with the felling of the forests came the extinction of the state's indigenous elk herd. Elk were abundant in presettlement Michigan, where they served as a staple game animal for the native people. The elk's disappearance ended a sad chapter for Michigan's environment that would take nearly a century to remedy.

With the logging companies gone and the forests slowly beginning to recover, a small herd of elk were reintroduced in 1918 near Wolverine in the upper Lower Peninsula. Under the watchful eye of the Michigan Department of Conservation and, later, the Michigan Department of Natural Resources (DNR), the herd flourished in the newly formed Pigeon River Country State Forest. By the 1960s, the 95,000-acre forest contained nearly 1,500 elk. Through continued habitat improvement and protection from uncontrolled hunting, the Pigeon River elk herd had grown into the largest herd of wild elk east of the Mississippi River.

As the elk herd grew, so did concerns that they would outgrow their range and begin to damage the forest and nearby cropland. To keep elk numbers in check, a strictly limited hunt was allowed in 1964 and 1965, inciting some protests, but a real threat to the elk herd was just around the corner.

In the early 1970s, oil was discovered beneath the Pigeon River Country State Forest. The specter of Michigan's elk range being overwhelmed by noisy pumps and the odor of crude oil galvanized the environmental and sportsmen's communities. After much heated public debate, many court battles, and, finally, compromise, a scaled-back plan was agreed upon. The agreement allowed limited drilling in the forest under tight regulatory control.

Today, the Pigeon River elk herd numbers between 800 and 900 animals. Elk-watching has become a favorite autumn pastime at the many viewing areas maintained by the DNR, and the annual elk-hunting lottery in 2007 drew 33,044 applications for 168 hunting permits. The Pigeon River Country State Forest's elk management plan has become a model of successful reintroduction and habitat maintenance.

Hunters studying elk range map, 1965. Archives of Michigan

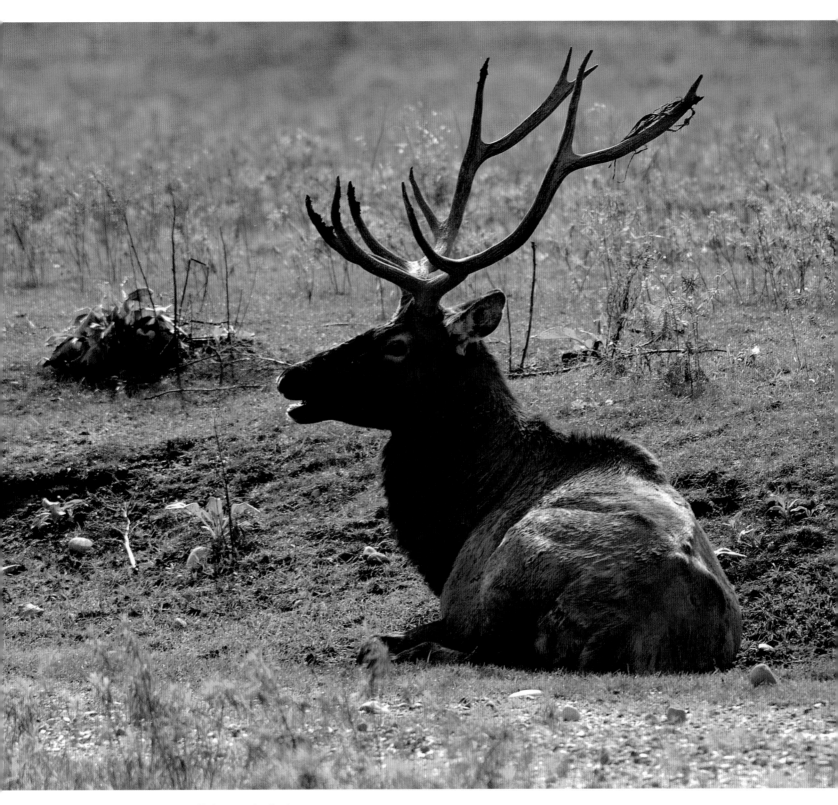

A huge bull elk on an elk farm in Gaylord

Hard Rock Mining

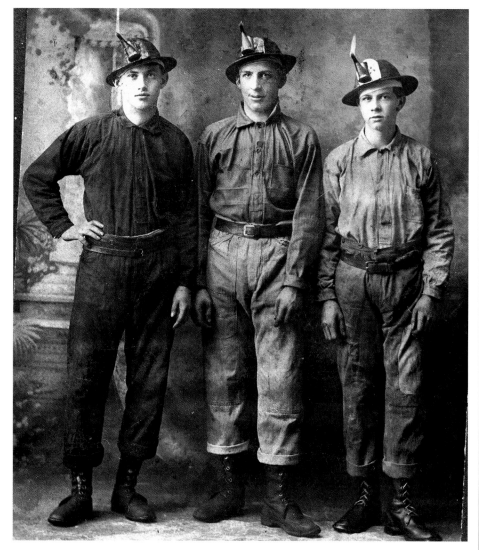

Copper miners on the Keweenaw Peninsula, 1900. Superior View

Native Michigan copper

Michigan's mining history began nearly seven thousand years ago in the northwestern region, near Lake Superior. Native Americans of the Copper Culture hammered out pure chunks of copper from the bedrock of the Keweenaw Peninsula and Isle Royale. They fashioned tools, weapons, and ornaments for their own use and for trade. Copper goods from northern Michigan were traded throughout North America long before European trading routes were established on the continent.

In the 1840s, northern Michigan was the scene of one of the nation's first mining rushes as people from all over the world converged on the Keweenaw Peninsula in search of copper. In a short time, several large mining companies had begun to bore and blast into the rock. For the next sixty years, the mine shafts of the Keweenaw Peninsula produced most of the world's copper. The copper boom lasted until the early twentieth century, when mining strikes and increased competition from the less expensive open-pit copper mines of the American West led to the demise of Keweenaw copper. The last copper mine in Michigan closed in 1997.

At the same time that copper mining was booming on the Keweenaw, three major iron ranges in the Upper Peninsula began to produce iron ore. After a slow start caused by high costs, transportation problems, and lack of capital, northern Michigan's iron mines hit their stride. By the 1890s, they were producing 80 percent of the nation's iron ore. Despite falling behind Minnesota in iron ore production at the turn of the twentieth century,

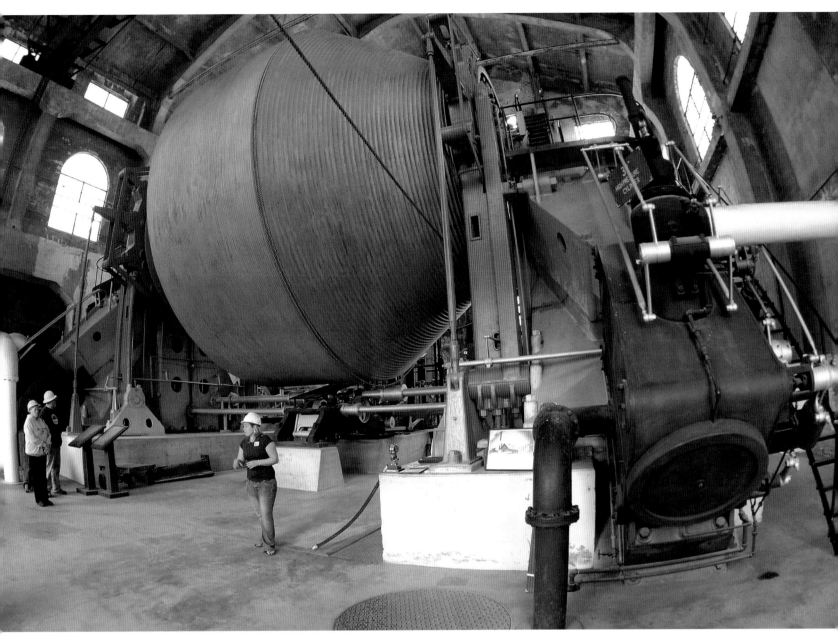

The hoist that lifted men and equipment in and out of the copper mine in Hancock

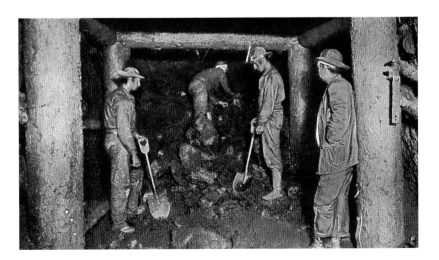

Mining was dangerous work. Voyageur Press archives

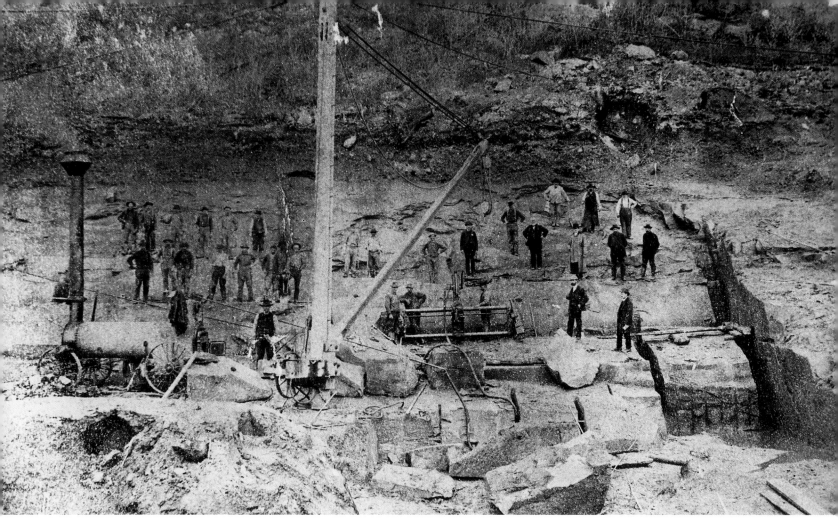

Open quarry, 1885. Marquette History Museum

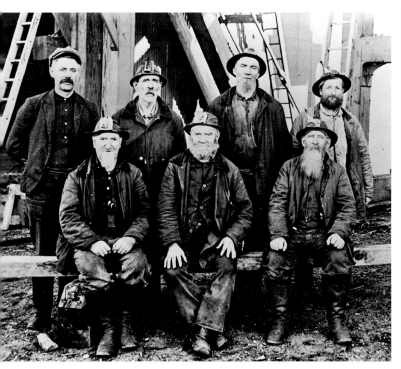

Copper miners on the Keweenaw Peninsula, 1890. Superior View

Michigan miners continued to supply iron ore throughout both World Wars and still tap into large reserves of low-grade ore.

The ancient saltwater sea that covered the Great Lakes region during the Middle Paleozoic Era left behind two important minerals: sodium chloride (salt) and calcium carbonate (limestone). Mining of both minerals has a long and important history in Michigan.

Twelve hundred feet beneath the city of Detroit, a labyrinth of tunnels passes through an immense deposit of rock salt. Throughout most of the twentieth century, the mine provided salt to the leather- and food-processing industries and to state and local municipalities for road de-icing.

The world's largest limestone quarry, the Oglebay Norton Calcite Quarry in Rogers City, ships between seven million and ten million net tons of high-grade calcium carbonate limestone each year. Limestone from the quarry is used in the cement and chemical industries and was once an important ingredient in smelting the iron ore from Michigan's iron mines.

A staircase leading to the hoist operator's station

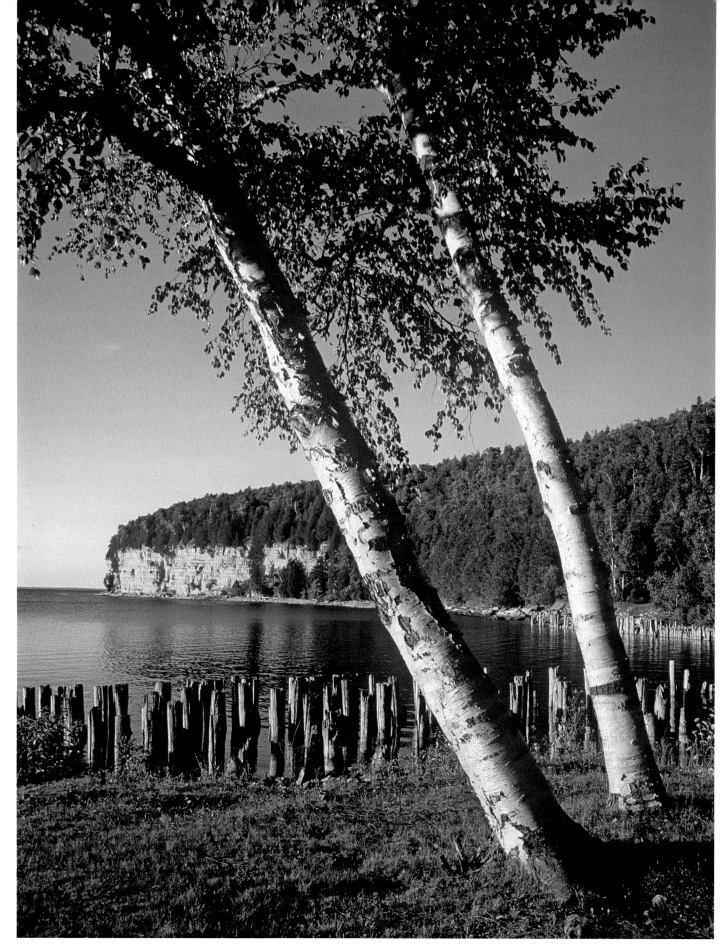

Snail Shell Harbor

FAYETTE

Everything came together for Fayette Brown, an agent for the Jackson Iron Company, when he stepped ashore at Snail Shell Harbor. The sheltered water of the harbor would provide a deepwater port for the company's ships, the hardwood forest would fire the kilns, the limestone cliffs that lined the shore of Bay DeNoc would provide the chemical catalyst, and the gentle hillside that overlooked the harbor would be a perfect setting for the town that the Jackson Iron Company would build. Everything was in place for a town that would turn raw iron ore from the mines of northern Michigan into processed pig iron.

From 1867 until 1891, Fayette, located on Michigan's Garden Peninsula, produced over a quarter million tons of pig iron. The five hundred or so residents of the town all worked for the Jackson Iron Company, living in company housing, purchasing food and supplies from the company store, and seeing the company doctor when they were injured or ill. Although the company controlled nearly every aspect of the workers' lives, they earned a decent wage for their long hours and most residents were content to live and work there.

The Jackson Iron Company closed its smelting operations at Fayette in 1891 amidst a decline in the charcoal iron market and advancements in iron smelting technology. Most of Fayette's workers moved out of town and on to new job opportunities, but the town was never completely deserted. In 1959, the Michigan Department of Natural Resources purchased the town and surrounding property, then began the painstaking task of restoring Fayette's buildings to their original condition. Special construction techniques were used that melded the old structure with the renovation work and made the repaired buildings appear as if they were all original construction.

Fayette Historic State Park offers a quiet and scenic place to enjoy nature and contemplate the history of Michigan's mining heritage. The park has a modern campground and a small dock for overnight mooring. Snail Shell Harbor and Bay DeNoc offer fine fishing opportunities, as well as five miles of hiking trails that lead through beech-maple forests and alongside spectacular white limestone cliffs.

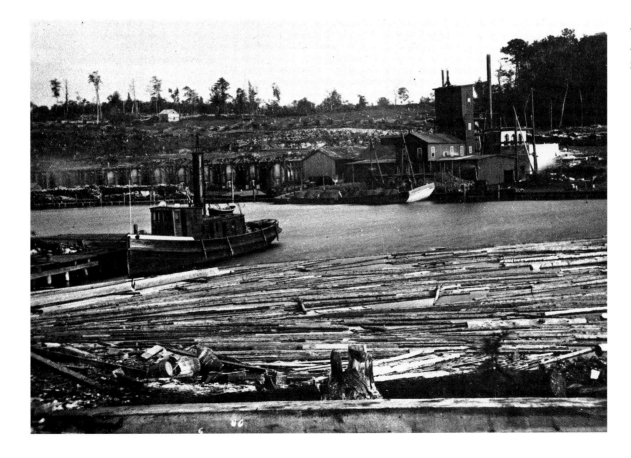

Local timber built Fayette, circa 1870.
Superior View

GRAND RAPIDS

Grand Rapids can trace its roots to a nineteenth-century trading post established by Frenchman Louis Campau, but the Grand River Valley where Campau established his outpost had already been home to native people for many years. The mound-building Hopewell Culture inhabited the region two thousand years before the arrival of Europeans, and several Odawa villages were there to greet Campau when he arrived in 1826.

When Michigan was granted statehood in 1837, Grand Rapids was still a small village in the wilderness, but things quickly began to change. New York land speculator John Ball had declared the area of western Michigan "the promised land" in 1836, sending Yankee settlers scrambling to purchase land in the Grand River Valley. By 1850, the population had grown to nearly 2,700 people, and on May 1 of that year, Grand Rapids officially became a city.

In the latter half of the nineteenth century, the lumber mills of Grand Rapids processed millions of board feet of southern Michigan timber, turning a large portion of the walnut, maple, and oak wood into fine furniture. Grand Rapids became known as Furniture City, a distinction that has carried over into the city's new position as a leader in the manufacture of office furniture.

Today, Grand Rapids is Michigan's second-largest city and the cultural and manufacturing center of western Michigan. The town boasts several world-class museums, including the Van Andel Museum Center, one of the country's oldest museums, and the new Gerald R. Ford Presidential Museum. Other attractions include the Frederick Meyer Gardens, the DeVos Place Convention Center, the John Ball Zoo, and a stretch of prime salmon-fishing river running right through town.

Grand Rapids

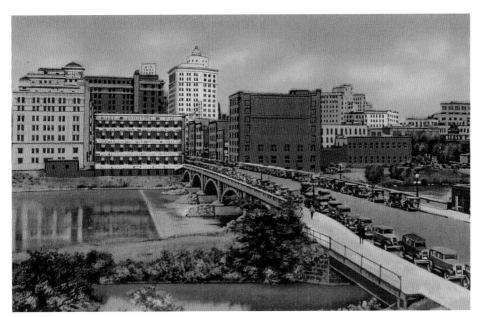

Grand Rapids, 1938. Voyageur
Press archives

Gerald R. Ford Presidential Museum

The end of the 1950 Port Huron to Mackinac Race. Superior View

PORT HURON TO MACKINAC RACE

The only two freshwater yacht races in the world share a common finish line: Mackinac Island. The oldest and longest race was established by the Chicago Yacht Club in 1898, although the race begun by the Bayview Yacht Club in Port Huron in 1925 has become the larger of the two with over 265 boats vying for trophies and a piece of Great Lakes history. The latter race is known as the Bayview Mackinac Race (aka Port Huron to Mackinac Race). It is a 235-mile-long test against time—and the dangerous waters of Lake Huron.

The race has followed several courses over the years. The original route followed the shore of Lake Huron from Port Huron to Mackinac Island. A new route in 1935 sent contenders around Cove Island in Georgian Bay. The race in 2007 followed a brand-new course up the Michigan shore of Lake Huron and around a weather buoy located forty-three miles offshore of Alpena.

The Port Huron to Mackinac Race has become a major social event, both at the starting and finishing lines. Festivities start early in Port Huron during race week, beginning with family night on the Thursday before the race. Families of the yachtsmen stroll past the slips along the Black River, admiring the boats and visiting the crews as they prepare for the big race.

Friday night is more festive, bringing out thousands of people to watch the yachtsmen party and heave water balloons at each other using improvised slingshots. When the cannon heralds the start of the race on Saturday afternoon, the crowds turn out once again to cheer the participants sailing north toward Mackinac Island. At the finish line, crowds gather on the lawn below Fort Mackinac early on Monday morning in anticipation of the first finishers.

The start of the 2008 Bayview Mackinac Race

STATE FAIRS

Michigan has many distinctive characteristics that set it apart from every other state in the Union. No other state has more freshwater coastline or is split into two geographical and culturally unique parts by five miles of water. And no other state can boast two state fairs; one is held in Detroit in the Lower Peninsula and the other is held in Escanaba in the Upper Peninsula.

The Lower Peninsula event has the distinction of being the oldest state fair in the country. In 1839, several promoters decided to hold a state fair in Ann Arbor. Unlike today, Ann Arbor in the early days of statehood was an outpost in Michigan's wilderness, well off the beaten path and reachable only by rutted wagon road and a single rail line from Detroit. The first Michigan State Fair attracted only two exhibitors and a few local visitors. The dismal showing put the idea of a state fair to rest until 1849, when the renewed Michigan State Fair was held in Detroit.

Ignoring the Ann Arbor debacle ten years earlier, historians consider the 1849 Detroit fair the country's oldest. A committee of the Michigan Agricultural Society selected different cities in Lower Michigan to host the fair until 1905, when department store magnate J. L. Hudson donated 135 acres of land at 8 Mile Road and Woodward Avenue as a permanent home for the fair. With the exception of the years that the country was embroiled in World War II, when the fair was cancelled, the state fair has occupied the site ever since.

The Upper Peninsula opened its first state fair in Escanaba on September 17, 1928, and as could be expected, the last few days of the weeklong event were plagued by cold, wet weather. Despite the off-putting weather, the first Escanaba fair was a hit that brought all the fun and activities of the UP's county fairs into one place for all to enjoy. The fair is now held in mid-August during the height of the UP summer season.

Today's fairgoers can expect equestrian and livestock competitions, first-rate music acts, carnival rides, and demonstrations of vintage machinery. The lumberjack antics of the Great Lakes Timber Show is a favorite of fairgoers who thrill to logrolling, speed-climbing, crosscut-sawing, and axe-throwing demonstrations that are done with tongue-in-cheek, family-oriented humor.

The Midway

The Timber Show at the UP State Fair

An advertisement from the 1928 UP State Fair. Delta County Historical Society

Draft horse team

The Irish Hills towers today

IRISH HILLS

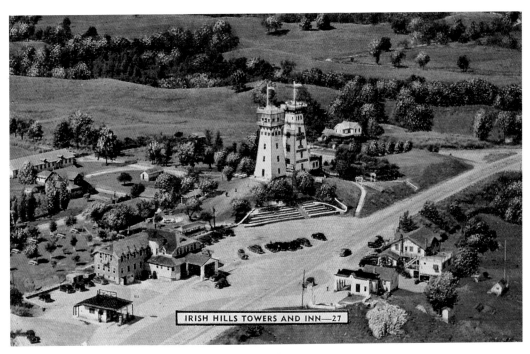

The Irish Hills towers, circa 1940. Voyageur Press archives

In the days of freeway and air travel between Detroit and Chicago, it is hard to imagine the grueling five-day journey that stagecoach travelers suffered to cross southern Michigan in the mid-nineteenth century. Halfway into the journey between the two cities, along the muddy and rutted road known as the Great Sauk Trail, travelers found a welcome refuge at the Walker Tavern in an oasis called the Irish Hills. The Great Sauk Trail is now a National Historic Route called U.S. Highway 12, the restored Walker Tavern is now a Michigan Historic State Park, and the beautiful, lake-studded Irish Hills are still a favorite vacation destination for city dwellers.

The Irish Hills were first settled by Irish immigrants who saw many similarities between the rolling green terrain of southern Michigan and their former home on the Emerald Isle. In 1854, a landmark of the Irish Hills, St. Joseph's Chapel, was built along the Great Sauk Trail by local Irish parishioners. The fieldstone church still serves parishioners from around the area.

With the advent of the interurban railroad and later the automobile, the Irish Hills became a favorite tourist destination for families living in southern Michigan. In 1922, Cedar Hills State Park (later renamed W. J. Hayes State Park) opened on Wampler's Lake in the heart of the Irish Hills. Summer cottages sprang up along the shorelines of the area's many lakes, and business owners vied for tourist dollars along U.S. 12.

As the popularity of the Irish Hills grew, U.S. 12 began to take on the look of a roadside carnival. In an effort to pry more dollars from the hands of tourists, one enterprising entrepreneur built a fifty-foot tower along the highway and charged visitors to climb the tower and enjoy the view. When the entrepreneur's neighbor, who was not happy with the tower bordering his property anyway, saw that money was to be made, he constructed his own tower and added ten feet to the height just for spite. Not to be outdone, the original tower builder put a fourteen-foot addition on his tower. The race for the sky ended several years later with both towers attaining a height of sixty-four feet. The towers still stand today, side by side, although both are in poor repair, an effort is under way to preserve them as a historical landmark.

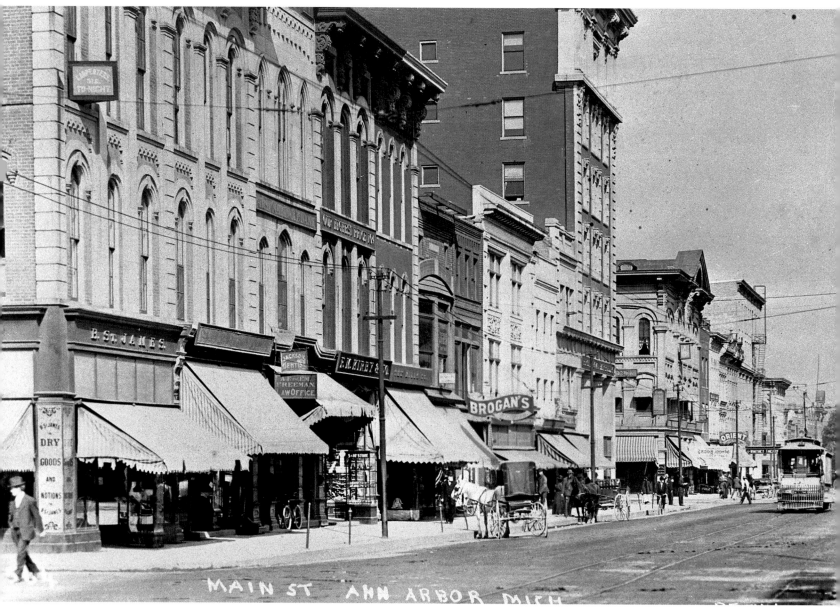

Ann Arbor, circa 1900. Superior View

ANN ARBOR

nn Arbor's first settlers arrived from Detroit in 1824, drawn by the promise of cheap land and fertile soil. They chose a spot on the banks of the Huron River in a grove of stately Burr oaks and called the settlement Annarbour to honor Ann Allen, the wife of one of the settlement's founders. In the years that followed, the settlement grew as gristmills, a tannery, and other businesses sprang up along the Huron River. Then, in 1837, the University of Michigan moved from its original location in Detroit to Ann Arbor, establishing a partnership that would forever define the town's growth, culture, and history.

The University of Michigan has grown to become one of the country's most prestigious public universities, and Ann Arbor has evolved alongside into a city alive with culture and fueled by research and high-tech industry. Ann Arbor's cultural scene revolves around the university's students and faculty.

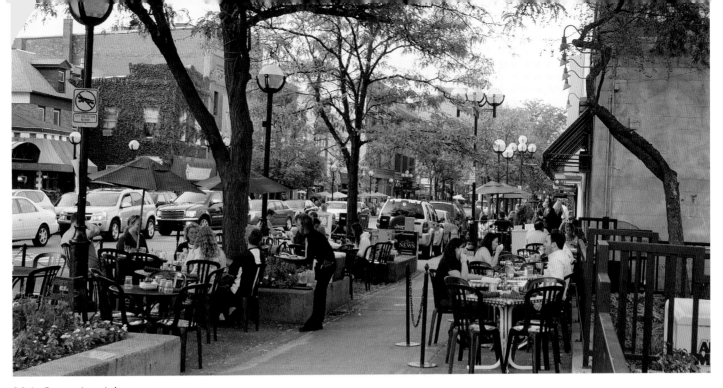

Main Street, Ann Arbor

The 1942 vintage State Theater

Coffee shops, bookstores, and restaurants for every taste line the downtown streets, and home games for the Michigan football team consistently pack the 100,000-plus-seat Michigan Stadium with maniacal Wolverines fans.

The small town that was home to a mere two thousand people when Michigan was granted statehood has become a thriving metropolis and one of Michigan's wealthiest cities. Ann Arbor is consistently ranked as one of the most livable cities in America and receives high marks for its public education system, numerous parks, public transportation, and the University of Michigan hospital and health care system. In addition to the many public events sponsored year-round by the university, the city draws over 500,000 people each July to the Ann Arbor Art Festival, one of the largest and most prestigious art shows in the country.

E PLURI BUS UNUM

CHIPPEWA COUNTY
COURT HOUSE

The Chippewa County Courthouse

SAULT SAINTE MARIE

The International Railroad Bridge, 1919. Voyageur Press archives

People have called the land alongside the rapids of the St. Mary's River home for nearly two thousand years. Before Father Jacques Marquette renamed the fledgling French settlement Sault Sainte Marie in 1668, the area was known to its Anishinabek residents as *Bahweting*, meaning "The Gathering Place." The turbulent water of the rapids was one of the Great Lake's prime fishing grounds and drew native people from around the region to spring and autumn fishing camps. The settlement at the "Soo" is the oldest in Michigan, and one of the oldest continuously occupied sites in North America.

The fur trade changed the Soo from a remote outpost into a major hub for the trappers and traders who plied the vast, unexplored waters of Lake Superior. A major obstacle to the flow of goods from Lake Superior to the lower lakes was the unnavigable rapids of the St. Mary's River. For more than one hundred years, cargo boats had to be unloaded and portaged around the rapids, a process that was exhausting, dangerous, and time-consuming. To remedy the problem, a crude lock was constructed that allowed small boats to bypass the rapids; over the next two centuries, the Soo Locks have evolved into an engineering marvel that has transformed shipping on Lake Superior.

Today, Sault Sainte Marie and its twin namesake city across the St. Mary's River provide a major link between the Upper Peninsula and Ontario. The International Bridge that spans the river between the towns is a well-used route for commerce and tourism between Canada and the United States. Lake Superior State University on the American side and Algoma University on the Canadian side bring many joint educational opportunities, along with a "college town" atmosphere, to the Soo.

The Sault Sainte Marie Tribe of the Chippewa also holds a large cultural and economic stake in the modern-day Soo. After a twenty-year struggle, the tribe was granted federal status in 1972, paving the way for the formation of an autonomous tribal government and allowing the tribe to engage in the highly lucrative casino business. The tribe currently owns and administers five casinos and many more nongaming businesses, making the Chippewa one of the Upper Peninsula's largest employers.

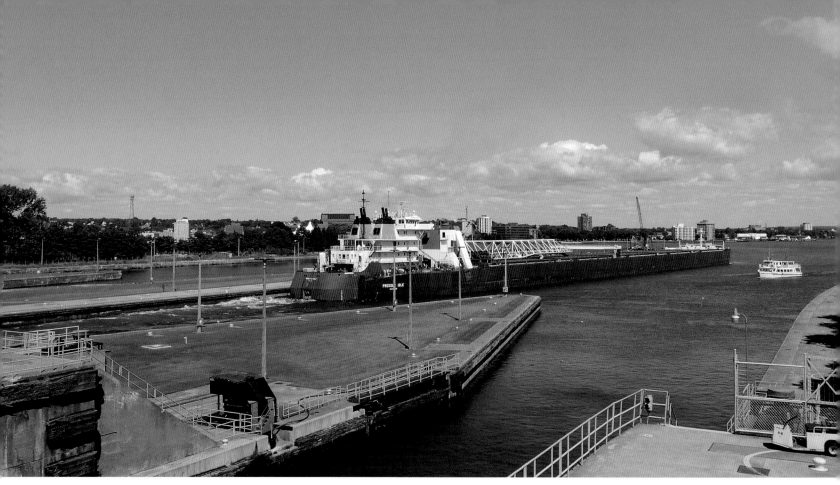

Modern freighter Presque Isle

THE SOO LOCKS

Connecting Lake Superior with Lake Huron, the locks at Sault Sainte Marie (or the "Soo Locks") are actually a series of locks that bypass the shallow, unnavigable rapids of the St. Mary's River. The Northwest Fur Company constructed the first lock on the Canadian side of the St. Mary's Rapids in 1797. The thirty-eight-foot-long lock enabled small boats loaded with furs and supplies to bypass the arduous portage around the rapids. Travelers to and from Lake Superior used this passageway until it was destroyed in the War of 1812.

Economic forces during the mid-nineteenth century prompted Congress to grant the State of Michigan 750,000 acres of land to compensate any company that could build a new lock within two years. In 1853, the Fairbanks Scale Company undertook the challenge and completed two new locks within the allotted time frame. The new locks were under the control of the state until 1881 when the federal government placed the locks under the jurisdiction of the Army Corps of Engineers.

The newest addition to the Soo Locks, the Poe Lock, was completed in 1968. At 1,200 feet long, 110 feet wide, and 32 feet deep, the Poe Lock can handle the largest of the freighters passing between the lakes. Grain, coal, and taconite (iron ore) are the main cargoes of the larger freighters, although workboats and pleasure craft make up the bulk of the lock's traffic. In an average year, approximately ten thousand vessels "lock through" the Soo.

Today, visitors can pass through the busiest locks in the world on one of the Soo Locks Boat Tours excursions. A variety of cruise packages offer everything from a lighthouse tour to a dinner cruise, a fireworks cruise, or a ride down the St. Mary's River from Sault Sainte Marie to Detour on Lake Huron. For a close look at the locks and the ships that pass through them, visit the Soo Locks on Engineers Day, held the last Friday in June. On this day, the security fence is opened, allowing visitors to get close enough to actually touch the freighters passing through the locks.

Construction of the Weitzel Lock, 1876. Archives of Michigan

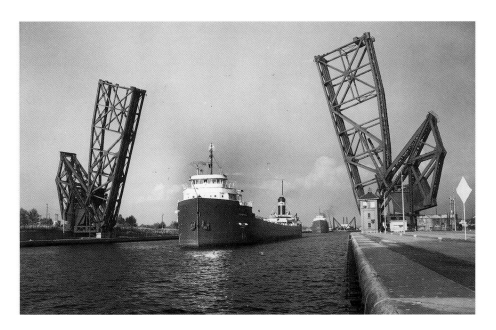

Freighter passing through the Soo Locks, 1963. Superior View

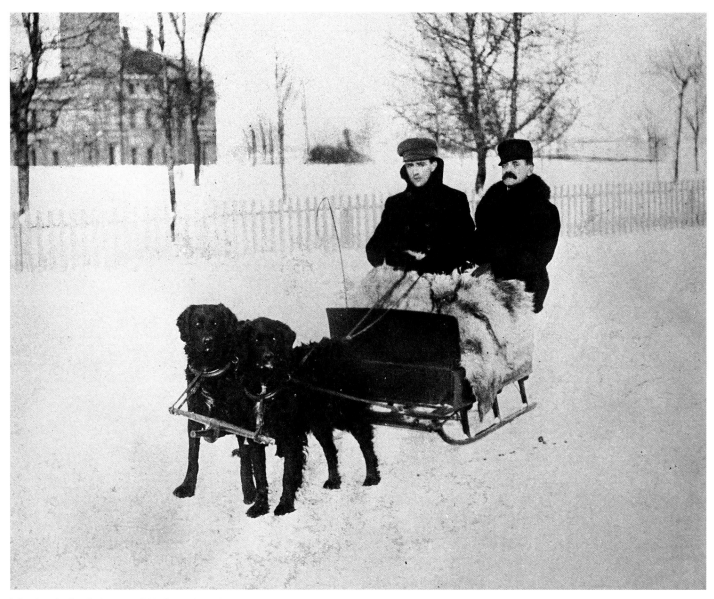

The family dogsled, circa 1880. Superior View

WINTER

Winter is Michigan's defining season. The winter season weeds out those who require the comfort of year-round sunshine and a temperate climate, and offers stark beauty and unlimited recreation to those who are willing to embrace the extreme cold. For Michigan's Native Americans, the winter drove them away from the shores of the Great Lakes and to the interior forests, where they hunted in small family groups until the spring thaw reopened the waterways. Nineteenth-century lumberjacks worked hard during the winter months, cutting trees and moving the timber with horse-drawn sleighs over ice roads. In the spring, when the rivers were high, the logs that had been stacked at the river's edge were floated downstream to the waiting mills.

The Great Lakes have a profound influence on Michigan's winter weather. The relatively warm water of the lakes moderates temperatures along the shoreline, consigning the extremely cold temperatures to Michigan's interior counties. The lakes

Snowmobiling

also provide abundant moisture for the production of snow. In some areas like Lake Superior's Keweenaw Peninsula, it is not uncommon to have several feet of snow on the ground for most of the winter.

Despite the chilling effect that driving through a winter storm has on travel, Michigan residents embrace the fluffy white stuff and the frigid temperatures. Winter sports like snowmobiling, cross-country and downhill skiing, and ice fishing keep businesses throughout the state busy from late November through mid-March—and give Michigan residents something to yearn for during the hot, muggy summer months.

Ice skating, circa 1910. Superior View

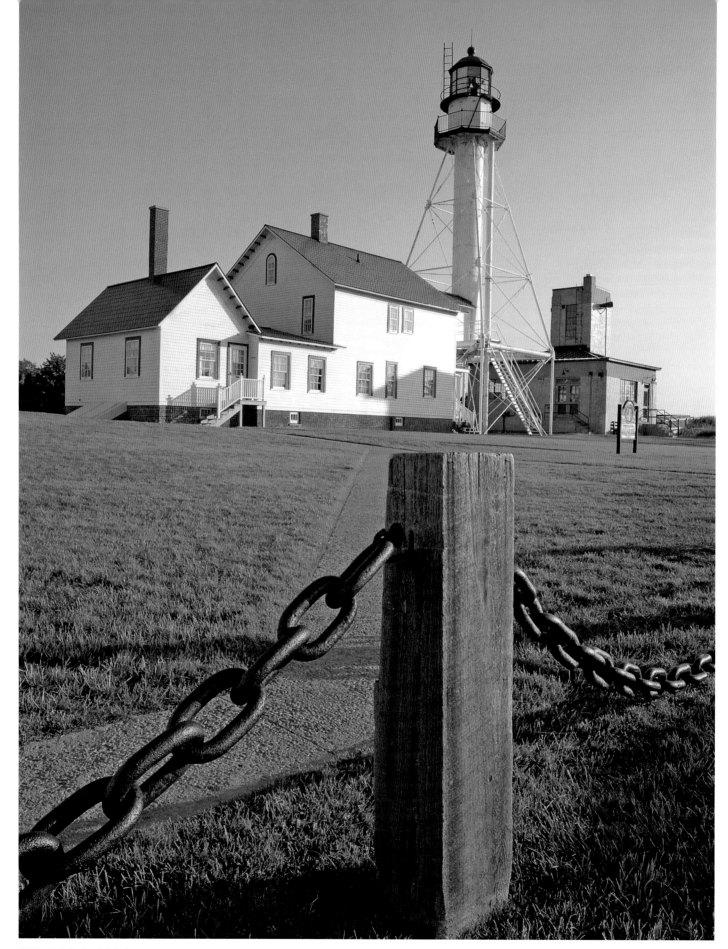

Whitefish Point Lighthouse

WHITEFISH POINT

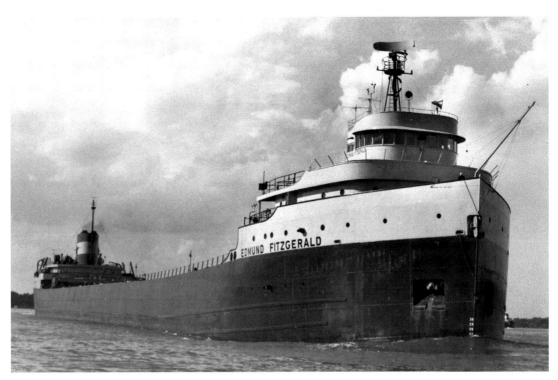

The Edmund Fitzgerald. Superior View

The cheery, red-roofed buildings and whitewashed light tower of Whitefish Point belie the deadly peril of nearby Lake Superior. As you stroll the grounds of the beautifully restored lighthouse or scan the sky with binoculars during spring or fall bird migration, it is hard to imagine that reaching Whitefish Point has often been the last desperate hope of a ship caught in a storm. On a sunny July afternoon, the risk the lake poses to nautical travel seems far removed.

Jutting into the eastern end of Lake Superior, Whitefish Point's position makes it a landmark for both sailors and migrating birds. The oldest active lighthouse on Lake Superior, Whitefish Point Lighthouse sits at the entrance to Whitefish Bay, a sheltered haven from the legendary storms on Superior. Whitefish Point is also a beacon for migratory raptors and songbirds making their annual autumn trek across Lake Superior from northern Canada.

The memories of the maritime tragedies that occurred around Whitefish Point are preserved at the Great Lakes Shipwreck Museum and the Whitefish Point Underwater Preserve. The museum houses artifacts salvaged from Lake Superior shipwrecks, including the ship's bell from the *Edmund Fitzgerald*, the legendary freighter that was lost with all twenty-nine crew members during a November gale in 1975. The museum is run by the Great Lakes Shipwreck Historical Society, a group of divers, teachers, and historians who banded together in 1978 to preserve and study the shipwrecks of the Great Lakes.

The Whitefish Point Underwater Preserve is one of eleven such underwater preserves in Michigan. It protects dozens of shipwrecks in a 376-square-mile area of Lake Superior and Whitefish Bay. Many of the shipwrecks lie in deep water beyond the range of recreational SCUBA equipment, but others—like the *M. M. Drake*, a freighter that sank in 1901, and the wooden schooner *Eureka*, lost in 1886—lie in only forty or fifty feet of water.

Whitefish Point has long been the last stop going north and the first stop heading south for migrating birds over Lake Superior. Each spring and autumn, tens of thousands of birds, including hawks, owls, eagles, songbirds, and waterfowl, pass over Whitefish Point to the delight of an army of birding enthusiasts who show up to witness the spectacle. The Whitefish Point Bird Observatory is adjacent to the Whitefish Point Lighthouse and the Great Lakes Shipwreck Museum. The observatory offers a network of foot trails leading to the point, a visitor center, a gift shop, and seasonal programs.

THE CALUMET THEATRE

To walk the streets of Calumet today, it is hard to imagine that this quiet town at the gateway to the Keweenaw Peninsula was once at the center of the largest copper-mining operation in the nation. In the mid-nineteenth century, workers from every corner of Europe poured into Calumet and nearby towns, seeking employment in the copper mines. The immigrants brought with them their religion, food, language, and cultural heritage that made Calumet a truly cosmopolitan city. The wealth that copper brought to the region fueled cultural and civic projects, including the Calumet Theatre.

In 1898, the village of Red Jacket (Calumet's original name) added a 1,200-seat opera house to the existing city hall building. Even though Red Jacket was about as far removed from the cultural centers of the United States as you could get, the new opera house became the only theater between New York and Chicago that had dressing rooms with electric lights and hot and cold running water; traveling performers gladly made Red Jacket a stop on their national tour.

The new theater attracted an amazing variety of big-name acts: John Phillip Sousa conducted his patriotic marches before sellout crowds, and Broadway stage legends Lillian Russell, Douglas Fairbanks, Lon Chaney, and Jason Robards performed there. Theater productions flourished until the 1920s, when the stage slowly began to give way to motion pictures.

With the advent of the Great Depression and the decline of the copper-mining industry in the region, the population around Red Jacket began to dwindle and public money for the Calumet Theatre's upkeep became scarce. Several owners operated the theater as a movie house until local theater productions returned in the 1960s.

Renovation on the auditorium was undertaken in 1975 as part of Calumet's centennial commemoration, and the outside façade of the theater was given a facelift in the 1980s. Infrastructure improvements have been ongoing ever since. The theater is now operated by the Calumet Theatre Company, a nonprofit cultural organization that presents sixty to eighty performing arts events each year, including music, dance, and theater. The building is open daily during the summer for guided tours.

The Calumet Theatre, circa 1900. Superior View

The proscenium arch

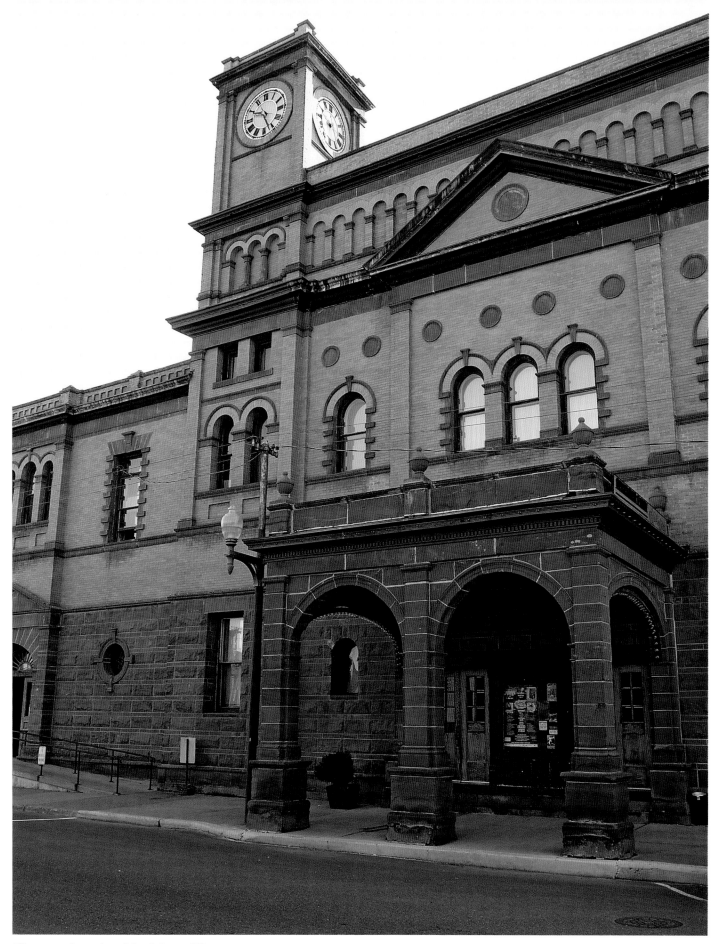

The restored exterior of the Calumet Theatre

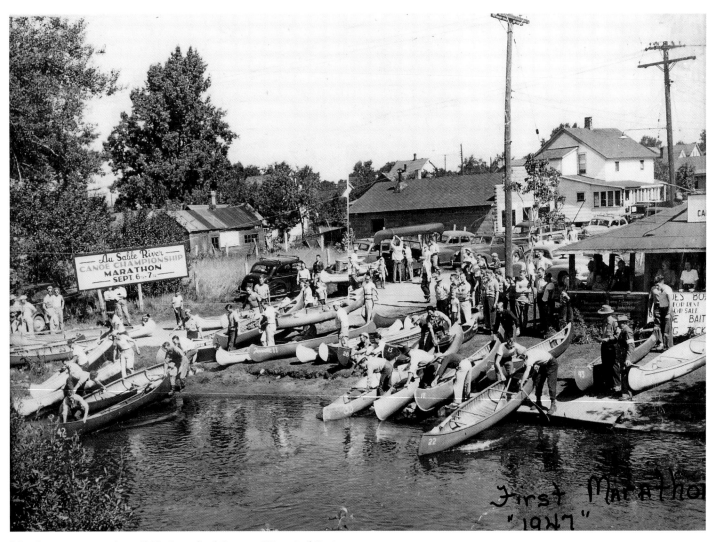

The first canoe marathon, 1947. Crawford County Historical Society

AuSable River Canoe Marathon

The boats sit in formation in front of the Grayling Post Office in the shadow cast by the late-afternoon sun. These are not your typical summer-camp canoes: bulky, fat, keeled, and heavy. And the racers who mill about in quiet anticipation for the gun to sound and the race to begin are not your typical weekend-warrior canoeists. Those people wouldn't last an hour in this race. The canoeists who finish will have to endure at least fourteen hours of flat-out, all-or-nothing paddling through the night and into the morning, down 120 miles of twisting, stump-studded river to the town of Oscoda on Lake Huron. Just to finish the race is laudable; just to enter is gutsy.

The Weyerhaeuser AuSable River Canoe Marathon, established in 1947, is recognized as the longest, richest, and toughest nonstop canoe race in North America. When the gun sounds at 9 o'clock on the last Saturday evening in July, around seventy teams will hoist their canoes over their heads, sprint down Grayling's main drag to the AuSable River, and throw themselves into the race. Prizes totaling $50,000 are split among the winners. The prize money is nice, but you can see in the faces of the contestants that the race itself is the real reason they are here.

The race is almost as tough on the spectators as it is on the competitors. Diehard fans spend all night driving from one

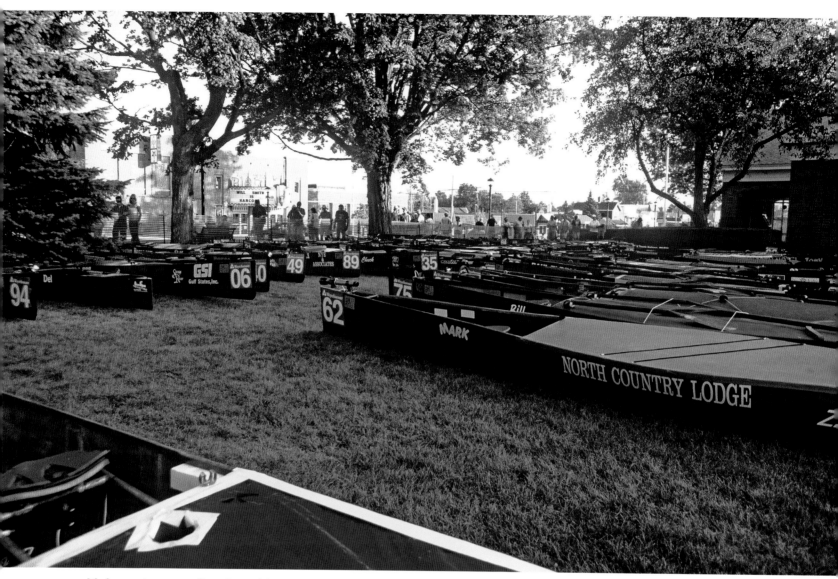

Modern racing canoes. Scott Reynolds

official timing and viewing site to the next, trying their best to stay in front of the pack leaders. Even in the wee hours of the morning, crowds of spectators gather on bridge overpasses to whoop and cheer as the racers fly into the lights of the officials who note the racers' numbers and times. Within a few seconds, the racers have passed into the downstream darkness, bound for the next checkpoint. Even after six hours of paddling, the lead canoe teams are hitting their stride at seventy or eighty strokes per minute.

The finish line in Oscoda is pure bedlam. Television cameras roll and spectators cheer wildly as the racers cruise into the shallows, pull themselves out of their canoes, and collapse into the water to feel the cold current of the AuSable River that flows around them and through them.

STATE PARKS

At the beginning of the twentieth century, when the loggers and miners had moved on to other job opportunities in the West, a new industry began to rise among the lakes and woods of Michigan: tourism. The resort towns along Lake Michigan had long been havens for summer travelers seeking to escape the heat and oppression of the inner city, but a new breed of vacationer—the kind who would suffer poor roads, a lack of travel amenities, and primitive conditions—were seeking out a place in Michigan's wilderness to pitch a tent. With a sense that secluded and scenic places needed to be set aside for people seeking to commune with the state's wild side, the Michigan Department of Conservation purchased two hundred acres of virgin pine forest near Interlochen in 1917 to become Michigan's first state park.

In the eight short years following the founding of Michigan's first state park, the number of state parks grew to fifty-seven and the number of visitors swelled from 200,000 to more than 2 million, including 77,534 campers. At the turn of the twenty-first century, 4 million campers enjoyed more than 13,000 state park campsites spread throughout the state. Many of Michigan's oldest state parks are still among its most visited: Grand Haven, Mears, Silver Lake, and Traverse City state parks were all established before 1920 and still fill to capacity nearly every summer weekend.

Michigan's state park system includes an array of different-size parks in a variety of settings. The largest park is the 60,000-acre Porcupine Mountains Wilderness State Park located in the western Upper Peninsula. One of the smallest state parks, Wagner Falls Scenic Site near Munising, occupies only 22 acres. State parks in Michigan are built around a variety of attractions, from popular beaches in the case of Holland and Petoskey state parks to historical sites like Colonial Michillimackinac and Fayette State Park. The state park system also includes several huge state recreation areas, such as the 20,000-acre Waterloo Recreation Area and the Pinckney Recreation Area, which covers more than 11,000 acres.

The Island Trail at Ludington State Park

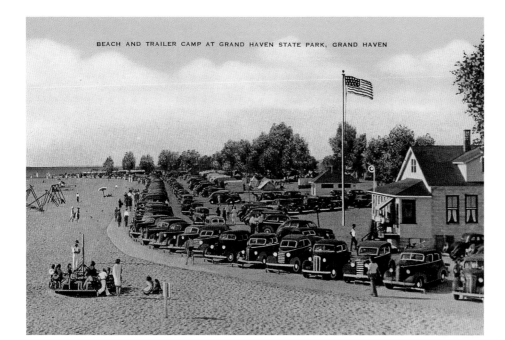

BEACH AND TRAILER CAMP AT GRAND HAVEN STATE PARK, GRAND HAVEN

Grand Haven State Park. Voyageur
Press archives

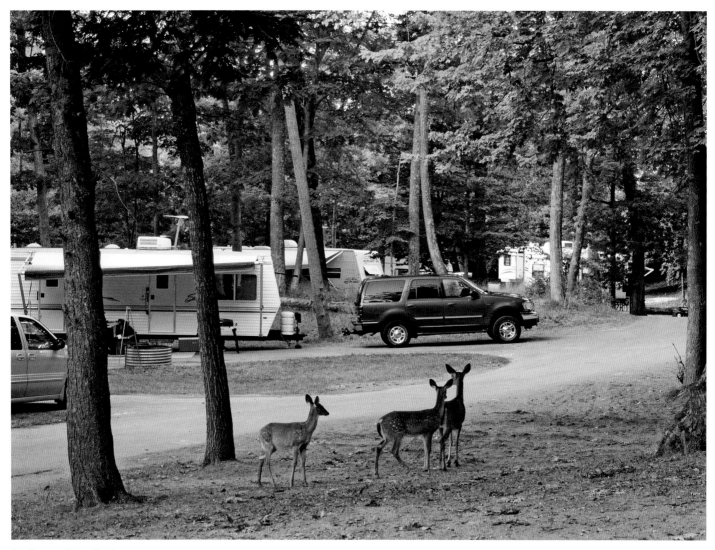

Ludington State Park

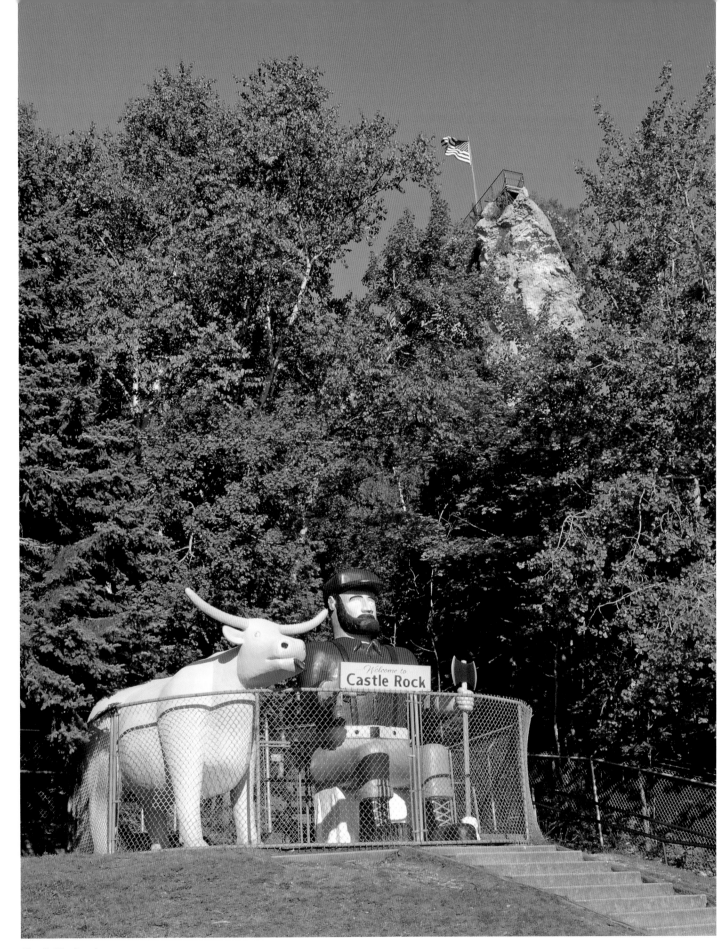

Castle Rock today

CASTLE ROCK

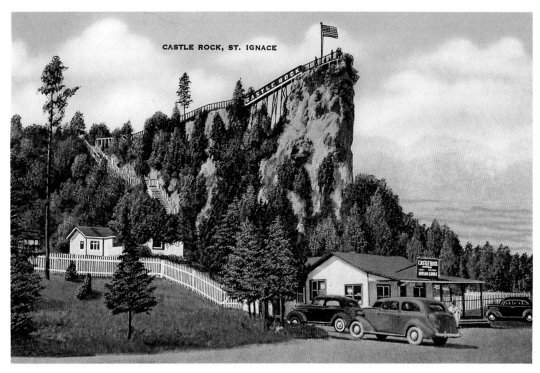

Castle Rock, circa 1941. Mark Eby

Just outside the town of St. Ignace along Interstate 75 is a classic Americana roadside attraction: Castle Rock. The rock itself is a distinctive spire of limestone that rises about two hundred feet above the forest floor and offers a commanding view of nearby Lake Huron and Mackinac Island and a glimpse of the Mackinac Bridge. Limestone outcrops are fairly common along the north shore of Lake Huron, but Castle Rock's obelisk shape and sheer height make it a magnet for curious people with a fondness for a spectacular view.

Seizing on the tourism potential, C. C. Eby, a photographer and businessman from St. Ignace, purchased the monolithic spire in 1928 along with a small tourist stand on the site. In the days before the Mackinac Bridge united Michigan's peninsulas, Eby used his photographic talents to draw tourists to the Upper Peninsula and the Straits of Mackinac area. At one time, he owned four different tourist attractions around St. Ignace; Castle Rock and Indian Village in St. Ignace are still owned and operated by the Eby family.

Today, for a nominal fee, visitors can traverse a well-maintained set of stairs to the top of the "castle" to see the changes that have occurred to the straits over the years. A statue of legendary lumberjack Paul Bunyan sitting on a stump, axe in hand, with his blue ox, Babe, by his side, also graces the premises. An old-fashioned souvenir shop, hawking everything from tee shirts to northern Michigan memorabilia, completes the classic, up-north tourist attraction experience.

ROADS

eing the automotive capital of the world necessitates being at the forefront of road-building and design, and throughout its history, Michigan has lived up to the challenge. The first Michigan roadmap produced by Congress in 1826 showed only three roads in the entire state; less than seventy-five years later, the state was crisscrossed with hundreds of miles of muddy wagon trails. Ironically, dealing with the poor condition of these trails in urban areas led a bicycling enthusiast named Horatio Earle to lobby Michigan's legislature for better road maintenance. Earle's success led to the formation of the Michigan State Highway Department in 1905, three years before Henry Ford's Model T began flooding the roadways.

To keep the state's ever-increasing number of motorists safe, Michigan has produced many traffic safety firsts. The nation's first four-way, three-color traffic signal was installed in Detroit in 1918, replacing the elevated platform known as a crow's nest from which a police officer directed traffic. Painted center lines, roadside parks, concrete roadways, and welcome centers were all developed and implemented in Michigan, along with the first highway material testing lab, which opened at the University of Michigan in 1912.

Today, the state of Michigan contains more than 120,000 miles of paved road, and an estimated 96 billion miles are driven on its roadways each year. The Michigan Department of Transportation employs thousands of engineers, traffic specialists, and maintenance workers; tens of thousands more workers are employed by private firms that build and maintain Michigan's roadways.

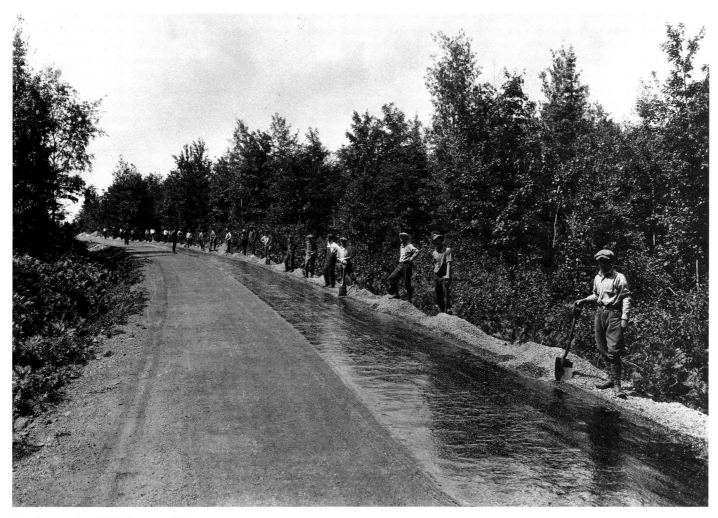

Road crew, circa 1920. Superior View

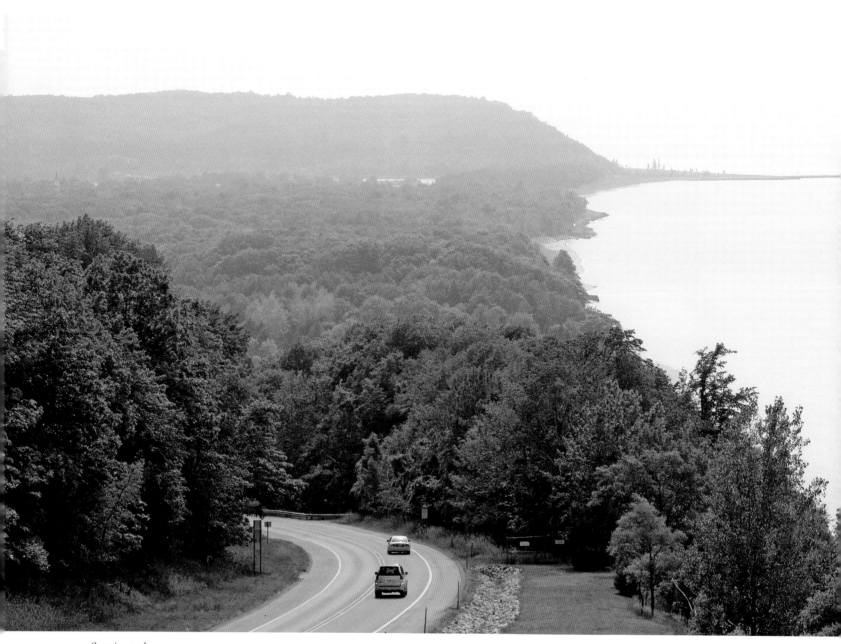

Scenic roadway

ISLE ROYALE NATIONAL PARK

Isle Royale Lighthouse, circa 1941. Voyageur Press archives

Rugged, remote, and without road or summer cottage, Isle Royale National Park sits in the far northwestern corner of Lake Superior, much closer to Minnesota and Ontario than to Michigan. The island park is the realm of hikers and backpackers, who arrive during the summer months by boat or seaplane to experience 572,000 acres of picturesque northern wilderness.

Raw copper deposits on the Greenstone Ridge, the island's glacially sculpted backbone, brought the first humans to Isle Royale about four thousand years ago. Native Americans of the Copper Culture hammered out chunks of rock containing copper ore, heated the rocks over fire, and then plunged the rocks into cold water to crack the stone and separate out the copper. These early miners were the first people in North America to use the process of annealing to harden the soft copper. Attempts at commercial copper mining on Isle Royale during the nineteenth century were short-lived due to the low quality of the copper and the harsh, isolated conditions on the island.

The bountiful fisheries amid the island's rocky shoals also drew human visitors to the remote island. During the days of the fur trade, the Northwest Fur Company set up fishing stations on the island to supply trading posts on western Lake Superior. Commercial fishing around Isle Royale continues today on a small scale, with fishermen taking whitefish, lake trout, and lake herring in their nets.

Albert Stoll Jr., a newspaper reporter from Detroit, planted the idea of making Isle Royale a national park in a series of editorials he wrote for the *Detroit News*. Stoll visited Isle Royale in 1920 and, like so many before and after him, fell in love with the rugged landscape and peaceful solitude. The process of turning the island into a national park took nearly two decades, but Isle Royale National Park was successfully founded in 1940 and the park was officially dedicated six years later.

Today, Isle Royale enjoys the status of International Biosphere Reserve, an honor bestowed on the island by the United Nations in 1981. A small lodge at Rock Harbor provides lodging and dining for a limited number of guests who don't wish to pack in their own supplies and shelter. Ferry service to the island is available from Houghton/Hancock or Copper Harbor, and a seaplane makes daily flights from Houghton, weather permitting of course.

Isle Royale National Park

INDEX

ABOUT THE AUTHOR/PHOTOGRAPHER

Michigan native Robert W. Domm is an outdoors writer and photographer specializing in nature and fine art images of the Great Lakes region. He is the author and photographer of *Lake Michigan Backroads* and *Backroads of Michigan*, and his images have appeared in many publications, including *Sierra*, *National Wildlife*, and *Outdoor Photographer*. He lives in Rives Junction, Michigan.